MY HEART OVERFLOWS

A TREASURY OF READINGS, ♦ POEMS, AND PRAYERS ♦ ON GRATITUDE

PARACLETE PRESS
Brewster, Massachusetts

2024 First Printing

My Heart Overflows: A Treasury of Readings, Poems, and Prayers on Gratitude

Copyright © 2024 by Paraclete Press, Inc.

ISBN 978-1-64060-961-7

Library of Congress Cataloging-in-Publication Data
Names: Paraclete Press.
Title: My heart overflows: A Treasury of Readings, Poems, and Prayers on Gratitude
Description: Brewster, MA : Paraclete Press, 2024. | Summary: "A Selection of writings on gratitude which will turn your heart to thankfulness and joy"-- Provided by publisher.
Identifiers: LCCN 2023057088 (print) | LCCN 2023057089 (ebook) | ISBN 9781640609617 | ISBN 9781640609624 (epub)
Subjects: LCSH: Gratitude--Religious aspects--Christianity.
Classification: LCC BV4647.G8 M899 2024 (print) | LCC BV4647.G8 (ebook) | DDC 234/.2--dc23/eng/20240206
LC record available at https://lccn.loc.gov/2023057088
LC ebook record available at https://lccn.loc.gov/2023057089

10 9 8 7 6 5 4 3 2 1

The pieces included in this book have been adapted for the contemporary reader.

Published by Paraclete Press
Brewster, Massachusetts | www.paracletepress.com
Printed in China

CONTENTS

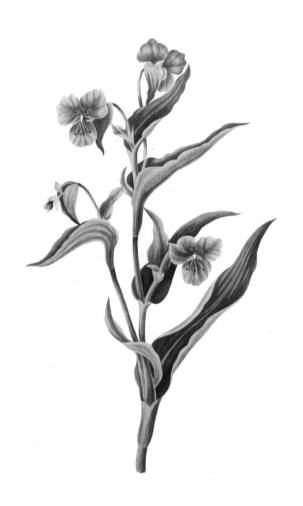

PREFACE

From ancient times to the present day, the benefits of cultivating gratitude have been well known.

The Roman philosopher Cicero boldly stated that gratitude is the parent of all other virtues and is the greatest of them all.

From the Jewish Scriptures to the second-century collection of rabbinic writings known as the *Pirke Avot* and beyond, Jews have cultivated the benefits of praise and gratitude.

Christians have long promoted an attitude of gratitude. For example, in the seventeenth century the Anglican bishop Thomas Ken penned the words "Praise God, from whom all blessings flow," the "Doxology" that is still sung in many English-speaking churches today.

The benefits of gratitude are not confined to a religious viewpoint. As the contemporary psychologist Amy Morin emphasizes, better physical and psychological health flow from an attitude of gratitude, as do better relationships, better self-esteem, better mental strength, even better sleep.

With this background in mind and having experienced the life-giving fruits of gratitude in our own hearts, the editors at Paraclete Press have gathered this collection of classic writings and beautiful artwork as an offering to our readers. We pray they will bless you.

On our journey through life, no matter the circumstances, let us join with those who have gone before us and with others who journey with us now in lifting up our hearts in gratitude.

So, amid the conflict, whether great or small,
Do not be discouraged, God is over all;
Count your many blessings, angels will attend,
Help and comfort give you to your journey's end.
—JOHNSON OATMAN (1856–1922)

I

GLORY BE TO GOD FOR DAPPLED THINGS

Gratitude for the Little Blessings

Henri Matisse (1869–1954), *Parrot Tulips (II)*

*When eating fruit,
remember the one who planted the tree.*
—VIETNAMESE PROVERB

◆ A PRAYER FOR GRATITUDE ◆

Most High, all powerful, good Lord,
to you all praise, glory and honor and all blessing;
to you alone, Most High, they belong
and no one is worthy of naming you.

Praised be you, my Lord,
with all your creatures,
especially Milord Brother Sun,
who brings day, and by whom you enlighten us;
he is beautiful, he shines with great splendor,
of you, Most High, he is the symbol.

Praised be you, my Lord, for Sister Moon and the Stars:
in the heavens you formed them,
clear, precious and beautiful.

Praised be you, my Lord, for Brother Wind
and for the air and for the clouds,
for the azure calm and for all climes
by which you give life to your creatures.

Praised be you, my Lord, for Sister Water,
who is very useful and humble,
precious and chaste.

Praised be you, my Lord, for Brother Fire,
by whom you enlighten the night:

he is beautiful and joyous,
indomitable and strong.

Praised be you, my Lord,
for Sister our mother the earth
who nourishes us and bears us,
and produces all kinds of fruits,
with the speckled flowers and the herbs.

—FRANCIS OF ASSISI (C. 1181–1226)

Thomas Chambers (1808–1869), *Connecticut Valley*

Gratitude is the fairest blossom
which springs from the soul.
—HENRY WARD BEECHER (1813–1887)

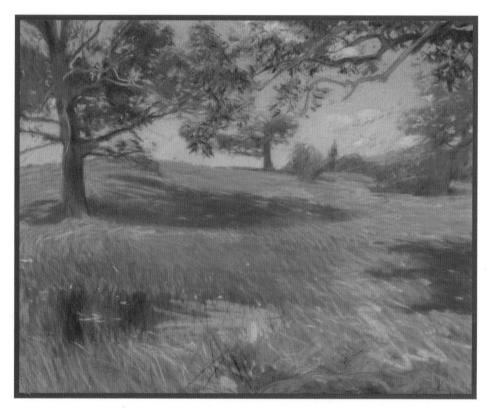

Childe Hassam (1859–1935), *Meadows*

WALDEN
◆ IS A PERFECT FOREST MIRROR ◆

Standing on the smooth sandy beach at the east end of the pond, in a calm September afternoon, when a slight haze makes the opposite shore line indistinct, I have seen whence came the expression, "the glassy surface of a lake." When you invert your head, it looks like a thread of finest gossamer stretched across the valley, and gleaming against the distant pine woods, separating one stratum of the atmosphere from another. You would think that you could walk dry under it to the opposite hills, and that the swallows which skim over might perch on it. Indeed, they sometimes dive below the line, as it were by mistake, and are undeceived. As you look over the pond westward you are obliged to employ both your hands to defend your eyes against the reflected as well as the true sun, for they are equally bright; and if, between the two, you survey its surface critically, it is literally as smooth as glass, except where the skater insects, at equal intervals scattered over its whole extent, by their motions in the sun produce the finest imaginable sparkle on it, or, perchance, a duck plumes itself, or, as I have said, a swallow skims so low as to touch it. . . .

You can even detect a water-bug (*Gyrinus*) ceaselessly progressing over the smooth surface a quarter of a mile off; for they furrow the water slightly, making a conspicuous ripple bounded by two diverging lines, but the skaters glide over it without rippling it perceptibly. When the surface is considerably agitated there are no skaters nor water-bugs on it, but apparently, on calm days, they leave their havens and adventurously glide forth from the shore by short impulses till they completely cover it.

It is a soothing employment, on one of those fine days in the fall when all the warmth of the sun is fully appreciated, to sit on a stump on such

a height as this, overlooking the pond, and study the dimpling circles which are incessantly inscribed on its otherwise invisible surface amid the reflected skies and trees. Over this great expanse there is no disturbance but it is thus at once gently smoothed away and assuaged, as, when a vase of water is jarred, the trembling circles seek the shore and all is smooth again. Not a fish can leap or an insect fall on the pond but it is thus reported in circling dimples, in lines of beauty, as it were the constant welling up of its fountain, the gentle pulsing of its life, the heaving of its breast. The thrills of joy and thrills of pain are undistinguishable. How peaceful the phenomena of the lake! Again the works of man shine as in the spring. Ay, every leaf and twig and stone and cobweb sparkles now at mid-afternoon as when covered with dew in a spring morning. Every motion of an oar or an insect produces a flash of light; and if an oar falls, how sweet the echo!

In such a day, in September or October, Walden is a perfect forest mirror, set round with stones as precious to my eye as if fewer or rarer. Nothing so fair, so pure, and at the same time so large, as a lake, perchance, lies on the surface of the earth. Sky water. It needs no fence. Nations come and go without defiling it. It is a mirror which no stone can crack, whose quicksilver will never wear off, whose gilding Nature continually repairs; no storms, no dust, can dim its surface ever fresh;—a mirror in which all impurity presented to it sinks, swept and dusted by the sun's hazy brush,—this the light dust-cloth,—which retains no breath that is breathed on it, but sends its own to float as clouds high above its surface, and be reflected in its bosom still.

—Henry David Thoreau (1817–1862), *Walden*, alt.

◆ PIED BEAUTY ◆

Glory be to God for dappled things—
 For skies of couple-colour as a brinded cow;
 For rose-moles all in stipple upon trout that swim;
Fresh-firecoal chestnut-falls; finches' wings;
 Landscape plotted and pieced—fold, fallow, and plough;
 And áll trádes, their gear and tackle and trim.

All things counter, original, spare, strange;
 Whatever is fickle, freckled (who knows how?)
 With swift, slow; sweet, sour; adazzle, dim;
He fathers-forth whose beauty is past change:
 Praise him.

—GERARD MANLEY HOPKINS (1844–1889)

O Lord, that lends me life,
Lend me a heart replete with thankfulness!
—WILLIAM SHAKESPEARE (1564–1616), *Henry VI*, Part 2

◆ OUR PRAYER OF THANKS ◆

For the gladness here where the sun is shining at
 evening on the weeds at the river,
Our prayer of thanks.

For the laughter of children who tumble barefooted and
 bareheaded in the summer grass,
Our prayer of thanks.

For the sunset and the stars, the women and the white
 arms that hold us,
Our prayer of thanks.

God,
If you are deaf and blind, if this is all lost to you,
God, if the dead in their coffins amid the silver handles
 on the edge of town, or the reckless dead of war
 days thrown unknown in pits, if these dead are
 forever deaf and blind and lost,
Our prayer of thanks.

God,
The game is all your way, the secrets and the signals and
 the system; and so for the break of the game and
 the first play and the last.
Our prayer of thanks.

—CARL SANDBURG (1878–1967), *Chicago Poems*

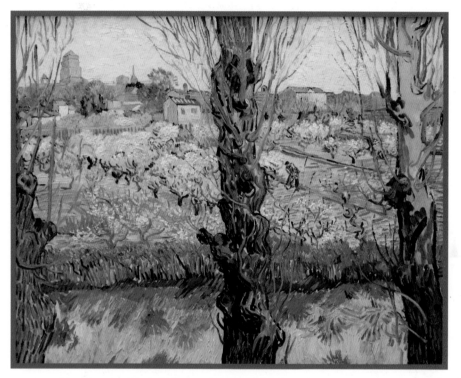

Vincent van Gogh (1853–1890), *View of Arles, Flowering Orchards*

The invariable mark of wisdom
is to see the miraculous in the common.
—RALPH WALDO EMERSON (1803–1882)

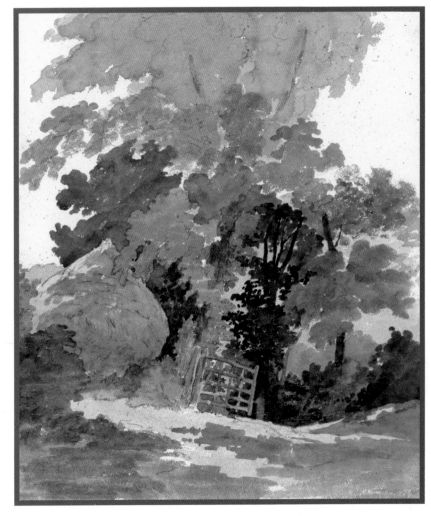

Robert Hills (1769–1844), *A Country Lane with Haystack and Gate*

We can complain because rose bushes have thorns,
or rejoice because thorns have roses.
—ALPHONSE KARR (1808–1890), *A Tour Round My Garden*

◆ PRECIOUS ◆

In February 1948 my mother and father arrived in this country on the *Queen Elizabeth* from England. To them it was the new land filled with new opportunities and thoughts of a new, invigorating natural beauty, for they both enjoyed hearing about Niagara Falls, the prairies of the Midwest, the Redwood forests, and the Grand Canyon. What they didn't expect was a blue bird.

As he entered the house coming home from his new job in New York City, my father announced to my mother with gusto, "I saw a blue bird! Can you imagine! A blue bird!" My mother said it was as though my father saw an exotic creature from Tahiti or paradise. Of course, my mother dismissed this. "You must have been mistaken."

But a few days later, when my father came home once again, my mother was waiting for him to announce with her own startled voice, "Yes! I saw it. I saw the blue bird!"

Today my mother still smiles when she tells me that the extraordinary bird was just an ordinary blue jay. "There are no blue birds in Belgium, so your father and I were innocently delighted to see this exotic bird for the first time." My mother recalls that there were also no cardinals in Belgium, and they were being sold in the market in fancy cages the same way we sell imported parrots in this country.

What is rare brings delight and value: gold, a painting by Michelangelo, an Olympic medal, a Nobel Prize, the Aurora Borealis. But the true mark of a poet, or a person who lives a life of gratitude and peace, is the person who recognizes the delight and value of ordinary things: spoons, daffodils, a clock ticking, the taste of chocolate ice cream, the smile of a child. And yet one person can see the magic of a blue jay, while someone else can call that same bird a curse.

Do you remember when Atticus Finch gave his son a rifle in Harper Lee's novel, *To Kill a Mockingbird*? He said to Jem, "Shoot all the blue jays you want, if you can hit 'em, but remember it's a sin to kill a mockingbird." According to Atticus blue jays were a nuisance eating up the crops, but mockingbirds—"they don't do one thing but sing their hearts out for us."

I felt sorry for the blue jays when I read that in the book. They look like royal birds in their blue and white feathers. I read that they can live for a quarter century, they can mimic the sound of a hawk, they are among the smartest birds, and they love acorns. A part of summer for me has always had, in the background, the trill of the cicadas and the distinctive cry of the blue jay, especially when our cat was slinking through the garden.

In Tolkien's *The Lord of the Rings*, Gollum coveted that gold ring, that precious ring, that ring that could extend the bearer's life for centuries. Of course, it destroyed Gollum. What we covet as rare and precious can, in someone else's eyes, be ludicrous and destructive.

To a young couple from Belgium the ordinary blue jay was a creature created by the gods of myth and fantasy. What is precious is not what glitters, but what shines within our own hearts.

—CHRIS DE VINCK, *Things That Matter Most* (1951–)

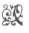

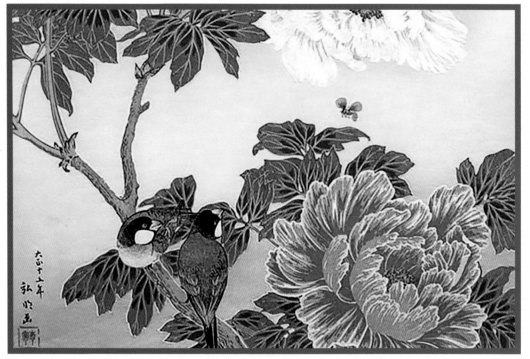

Shotei Takahashi (1871–1945), *Peony and Paddy Birds*

*Rest is not idleness, and to lie sometimes
on the grass under trees on a summer's day,
listening to the murmur of the water,
or watching the clouds float across the sky,
is by no means a waste of time.*
—JOHN LUBBOCK (1834–1913), *The Use of Life*

Wilkie said, "Sit right down at this table.
Here is a yellow pad and a ballpoint pen. I want you
to write down your blessings." . . . The ship of my life
may or may not be sailing on calm seas. The challenging
days of my existence may or may not be bright and
promising. Stormy or sunny days, glorious or lonely nights,
I maintain an attitude of gratitude. If I insist on being
pessimistic, there is always tomorrow. Today I am blessed.

—Maya Angelou (1928–2014)

The unthankful heart discovers no mercies;
but the thankful heart will find,
in every hour, some heavenly blessings.
—Henry Ward Beecher (1813–1887)

ALL THINGS
◆ BRIGHT AND BEAUTIFUL ◆

All things bright and beautiful,
All creatures great and small,
All things wise and wonderful,
The Lord God made them all.

Each little flower that opens,
Each little bird that sings,
He made their glowing colours,
He made their tiny wings.

The purple-headed mountain,
The river running by,
The sunset and the morning,
That brightens up the sky;

The cold wind in the winter,
The pleasant summer sun,
The ripe fruits in the garden,
He made them every one:

The tall trees in the greenwood,
The meadows where we play,
The rushes by the water,
We gather every day;

He gave us eyes to see them,
And lips that we might tell,
How great is God Almighty,
Who has made all things well.

All things bright and beautiful,
All creatures great and small,
All things wise and wonderful,
The Lord God made them all.

—CECIL FRANCES ALEXANDER (1818–1895)

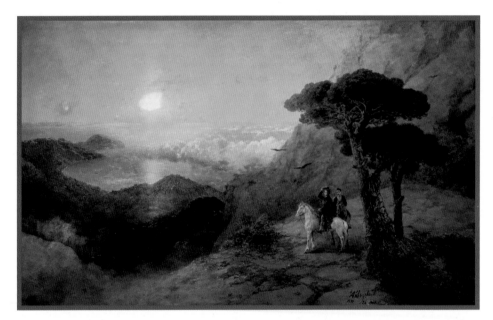

Ivan Aivazovsky (1817–1900), *Pushkin at the Top of the Ai-Petri Mountain*

Cultivate the habit of being grateful
for every good thing that comes to you,
and to give thanks continuously.
And because all things have contributed to your advancement,
you should include all things in your gratitude.
—RALPH WALDO EMERSON (1803–1882)

◆ THANKS ◆

How to depart and not thank
animals and most of all the cat
for being so separate and for teaching us
with its whole body the wisdom of focus

Thank you walls
huge invisible photos of my life
Thank you air
for patiently accepting my loneliness

Thank you my crowded desk
untiring secretary
I've written so many tears into you
that I've become one of your lame legs

And you I thank for knowledge
fragile tea-cup
you who taught me how to depart
There are things worth more than we ourselves

Just as before a wedding I'll have no time to thank you
all corners and radiators
I thank every spoon
God bless you since who else would bless you

And now depart all of you along with the crowd of holy statues
I've had enough of you and enough of thanking
The silent night looks at us with the eye of the abyss
What are we in that dark pupil

—ANNA KAMIEŃSKA (1920–1986), *Astonishments*

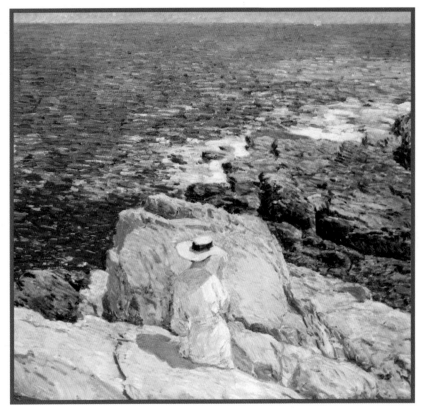

Childe Hassam (1859–1935), *The South Ledges, Appledore*

Life could be limitless joy,
if we would only take it for what it is,
in the way it is given to us.
—LEO TOLSTOY (1828–1910)

We are all in the gutter,
but some of us are looking at the stars.
—OSCAR WILDE (1854–1900), *Lady Windermere's Fan*

"'Miss March: Dear Madam—'"

"How nice it sounds! I wish some one would write to me so!" said Amy, who thought the old-fashioned address very elegant.

"'I have had many pairs of slippers in my life, but I never had any that suited me so well as yours,'" continued Jo. "'Heart's-ease is my favorite flower, and these will always remind me of the gentle giver. I like to pay my debts, so I know you will allow "the old gentleman" to send you something which once belonged to the little granddaughter he lost. With hearty thanks, and best wishes, I remain—

"'Your grateful friend and humble servant,—JAMES LAURENCE.'"

"There, Beth, that's an honor to be proud of, I'm sure! Laurie told me how fond Mr. Laurence used to be of the child who died, and how he kept all her little things carefully. Just think; he's given you her piano! That comes of having big blue eyes and loving music," said Jo, trying to soothe Beth, who trembled and looked more excited than she had ever been before.

"See the cunning brackets to hold candles, and the nice green silk, puckered up with a gold rose in the middle, and the pretty rack and stool, all complete," added Meg, opening the instrument and displaying its beauties.

"'Your humble servant, James Laurence'; only think of his writing that to you. I'll tell the girls; they'll think it's splendid," said Amy, much impressed by the note.

"Try it, honey; let's hear the sound of the baby pianny," said Hannah, who always took a share in the family joys and sorrows.

So Beth tried it, and every one pronounced it the most remarkable piano ever heard. It had evidently been newly tuned, and put in apple-pie order; but, perfect as it was, I think the real charm of it lay in the happiest of all happy faces which leaned over it, as Beth lovingly touched the beautiful black and white keys, and pressed the shiny pedals.

"You'll have to go and thank him," said Jo, by way of a joke; for the idea of the child's really going, never entered her head.

"Yes, I mean to; I guess I'll go now, before I get frightened thinking about it"; and, to the utter amazement of the assembled family, Beth walked deliberately down the garden, through the hedge, and in at the Laurences' door.

"Well, I wish I may die, if it ain't the queerest thing I ever see! The pianny has turned her head; she'd never have gone, in her right mind," cried Hannah, staring after her, while the girls were rendered quite speechless by the miracle.

They would have been still more amazed, if they had seen what Beth did afterward. If you will believe me, she went and knocked at the study door, before she gave herself time to think; and when a gruff voice called out, "Come in!" she did go in, right up to Mr. Laurence, who looked quite taken aback, and held out her hand, saying, with only a small quaver in her voice, "I came to thank you, sir, for . . ." But she didn't finish, for he looked so friendly that she forgot her speech and, only remembering that he had lost the little girl he loved, she put both arms round his neck and kissed him.

If the roof of the house had suddenly flown off, the old gentleman wouldn't have been more astonished. But he liked it. Oh dear, yes, he liked it amazingly! And was so touched and pleased by that confiding little kiss that all his crustiness vanished, and he just set her on his knee, and laid his wrinkled cheek against her rosy one, feeling as if he had got his own little

granddaughter back again. Beth ceased to fear him from that moment, and sat there talking to him as cosily as if she had known him all her life; for love casts out fear, and gratitude can conquer pride. When she went home, he walked with her to her own gate, shook hands cordially, and touched his hat as he marched back again, looking very stately and erect, like a handsome, soldierly old gentleman, as he was.

When the girls saw that performance, Jo began to dance a jig, by way of expressing her satisfaction; Amy nearly fell out of the window in her surprise, and Meg exclaimed, with uplifted hands, "Well, I do believe the world is coming to an end!"

—Louisa May Alcott (1832–1888), *Little Women*

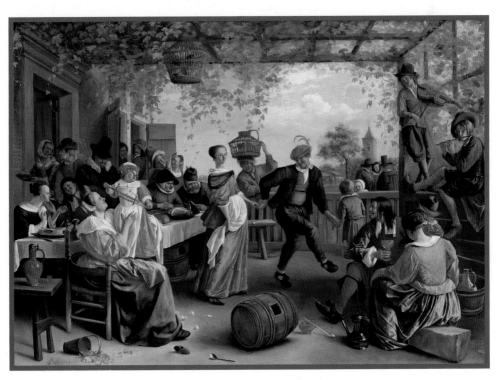

Jan Steen (1626–1679), *The Dancing Couple*

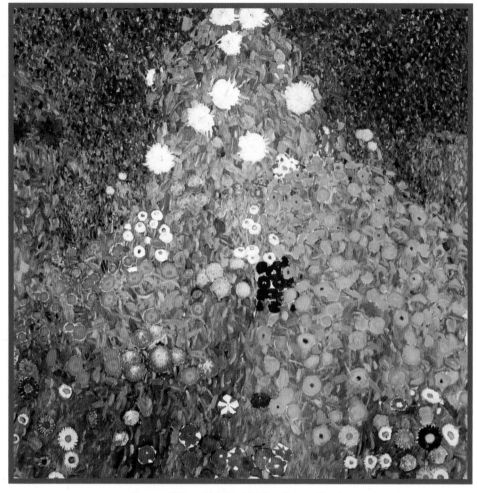

Gustav Klimt (1862–1918), *Flower Garden*

*In ordinary life we hardly realize that we receive a
great deal more than we give, and that it is only with
gratitude that life becomes rich.*
—DIETRICH BONHOEFFER (1906–1945)

What if the little rain should say,
"So small a drop as I
Can ne'er refresh the thirsty earth,
I'll tarry in the sky!"

What if a shining beam of noon
Should in its fountain stay,
Because its feeble light alone
Is not enough for day!

Doth not each rain-drop help to form
The cool refreshing shower?
And every ray of light to warm
And beautify the flower?

—WILLIAM CUTTER (1847–1918)

◆ SIGNS ◆

In time of drought, let us be
thankful for this very gentle rain,

a gift not to be disdained
though it is little and brief,

32

reaching no great depth, barely
kissing the leaves' lips. Think of it as

mercy. Other minor blessings may
show up—tweezers for splinters,

change for the parking meter,
a green light at the intersection,

a cool wind that lifts away summer's
suffocating heat. An apology after

a harsh comment. A word that opens
an unfinished poem like a key in a lock.

—LUCI SHAW (1928–), *Eye of the Beholder*

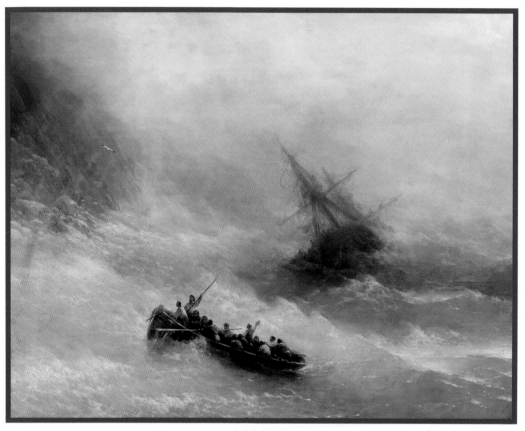

Ivan Aivazovsky (1817–1900), *The Rainbow*

All things are perceived in the light of charity,
and hence under the aspect of beauty;
for beauty is simply reality seen with the eyes of love.
—EVELYN UNDERHILL (1875–1941)

◆ A SONG OF THANKS ◆

For the sun that shone at the dawn of spring,
For the flowers which bloom and the birds that sing,
For the verdant robe of the gray old earth,
For her coffers filled with their countless worth,
For the flocks which feed on a thousand hills,
For the rippling streams which turn the mills,
For the lowing herds in the lovely vale,
For the songs of gladness on the gale,—
From the Gulf and the Lakes to the Oceans' banks,—
Lord God of Hosts, we give Thee thanks!

For the farmer reaping his whitened fields,
For the bounty which the rich soil yields,
For the cooling dews and refreshing rains,
For the sun which ripens the golden grains,
For the bearded wheat and the fattened swine,
For the stalled ox and the fruitful vine,
For the tubers large and cotton white,
For the kid and the lambkin frisk and blithe,
For the swan which floats near the river-banks,—
Lord God of Hosts, we give Thee thanks!

For the pumpkin sweet and the yellow yam,
For the corn and beans and the sugared ham,
For the plum and the peach and the apple red,
For the dear old press where the wine is tread,
For the cock which crows at the breaking dawn,

And the proud old "turk" of the farmer's barn,
For the fish which swim in the babbling brooks,
For the game which hide in the shady nooks,—
From the Gulf and the Lakes to the Oceans' banks—
Lord God of Hosts, we give Thee thanks!

For the sturdy oaks and the stately pines,
For the lead and the coal from the deep, dark mines,
For the silver ores of a thousand fold,
For the diamond bright and the yellow gold,
For the river boat and the flying train,
For the fleecy sail of the rolling main,
For the velvet sponge and the glossy pearl,
For the flag of peace which we now unfurl,—
From the Gulf and the Lakes to the Oceans' banks,—
Lord God of Hosts, we give Thee thanks!

For the lowly cot and the mansion fair,
For the peace and plenty together share,
For the Hand which guides us from above,
For Thy tender mercies, abiding love,
For the blessed home with its children gay,
For returnings of Thanksgiving Day,
For the bearing toils and the sharing cares,
We lift up our hearts in our songs and our prayers,—
From the Gulf and the Lakes to the Oceans' banks,—
Lord God of Hosts, we give Thee thanks!

—EDWARD SMYTH JONES (1881–1968)

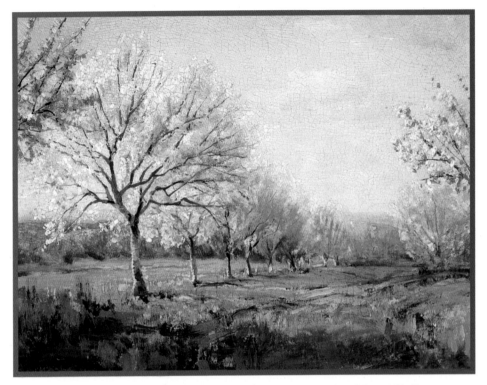

Robert Julian Onderdonk (1882–1922), *Peach Orchard on Maverick's Farm*

None is more impoverished than the one who has no gratitude. Gratitude is a currency that we can mint for ourselves and spend without fear of bankruptcy.
—FRED DE WITT VAN AMBURGH (1866–1944)

The beauty of the world is Christ's tender smile coming to us through matter.
—SIMONE WEIL (1909–1943)

MY WHOLE BODY IS ALIVE
◆ TO THE CONDITIONS ABOUT ME ◆

It seems to me that there is in each of us a capacity to comprehend the impressions and emotions which have been experienced by mankind from the beginning. Each individual has a subconscious memory of the green earth and murmuring waters, and blindness and deafness cannot rob him of this gift from past generations. This inherited capacity is a sort of sixth sense—a soul-sense which sees, hears, feels, all in one. . . .

What a joy it is to feel the soft, springy earth under my feet once more, to follow grassy roads that lead to ferny brooks where I can bathe my fingers in a cataract of rippling notes, or to clamber over a stone wall into green fields that tumble and roll and climb in riotous gladness! . . .

When a rainy day keeps me indoors, I amuse myself after the manner of other girls.

If I happen to be all alone and in an idle mood, I play a game of solitaire, of which I am very fond. I use playing cards marked in the upper right-hand corner with braille symbols which indicate the value of the card.

If there are children around, nothing pleases me so much as to frolic with them. I find even the smallest child excellent company, and I am glad to say that children usually like me. They lead me about and show me the things they are interested in. Of course the little ones cannot spell on their fingers; but I manage to read their lips. If I do not succeed they resort to dumb show. Sometimes I make a mistake and do the wrong thing. A burst of childish laughter greets my blunder, and the pantomime begins all over again. I often tell them stories or teach them a game, and the winged hours depart and leave us good and happy.

—HELEN KELLER (1880–1968), *The Story of My Life*

◆ ATTENDING ◆

—Simone Weil called this "prayer"

You begin with a singular gaze into any
thing, any Other. As you witness the moment
you practice the discipline of detail. Focus,
allowing yourself the access of steady regard.
It senses your attention and you will
find yourself joined in mutual love.

—Pebble. Bare twig. Raindrop hanging from
twig—a lens for landscape to enlighten the eye.
—Blue hyacinth, its invisible fragrance
drowning the air as you open the door.
Breathe it until it fills and lifts you.
—Thunder, so unambiguously itself
unfurling its huge sail over heaven.
Giver of rain, and green lettuce. Let it come
and offer your thanks.

A holy silence, as the church fills. Hearts wait.
The priest's homily before Eucharist,
and then, the Host taken without hesitation by our
waiting mouths. Let each be so present that
it leaves its truth, its hint of the real, its crease
in memory. Inhabit it with simplicity,
and find there a wholeness of intention.

—Luci Shaw (1928–), *Eye of the Beholder*

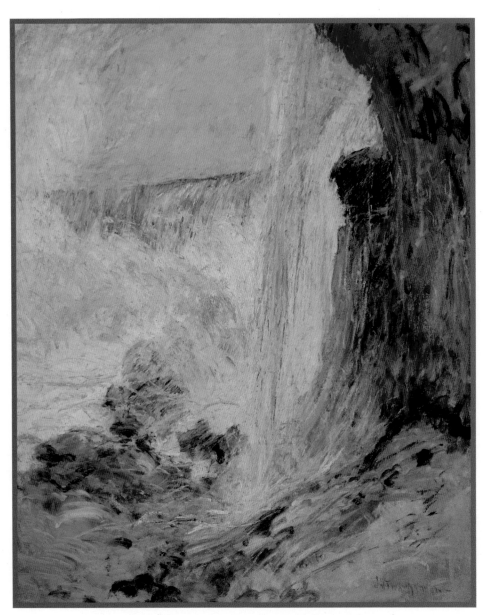

John Henry Twatchman (1853–1902), *The Rainbow's Source*

The harp at Nature's advent strung
Has never ceased to play;
The song the stars of morning sung
Has never died away.

40

And prayer is made, and praise is given,
By all things near and far;
The ocean looketh up to heaven,
And mirrors every star.

Its waves are kneeling on the strand,
As kneels the human knee,
Their white locks bowing to the sand,
The priesthood of the sea!

They pour their glittering treasures forth,
Their gifts of pearl they bring,
And all the listening hills of earth
Take up the song they sing.

The green earth sends its incense up
From many a mountain shrine;
From folded leaf and dewy cup
She pours her sacred wine.

The mists above the morning rills
Rise white as wings of prayer;
The altar-curtains of the hills
Are sunset's purple air.

The winds with hymns of praise are loud,
Or low with sobs of pain,—
The thunder-organ of the cloud,
The dropping tears of rain.

With drooping head and branches crossed
The twilight forest grieves,
Or speaks with tongues of Pentecost
From all its sunlit leaves.

The blue sky is the temple's arch,
Its transept earth and air,
The music of its starry march
The chorus of a prayer.

So Nature keeps the reverent frame
With which her years began,
And all her signs and voices shame
The prayerless heart of man.

—JOHN GREENLEAF WHITTIER (1807–1892)

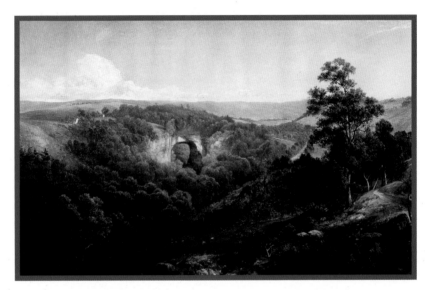

David Johnson (1827–1908), *Natural Bridge, Virginia*

Gratitude turns what we have into enough.
—Aesop (c. 620–564 bc)

◆ THE PUMPKIN ◆

Oh, greenly and fair in the lands of the sun,
The vines of the gourd and the rich melon run,
And the rock and the tree and the cottage enfold,
With broad leaves all greenness and blossoms all gold,
Like that which o'er Nineveh's prophet once grew,
While he waited to know that his warning was true,
And longed for the storm-cloud, and listened in vain
For the rush of the whirlwind and red fire-rain.

On the banks of the Xenil the dark Spanish maiden
Comes up with the fruit of the tangled vine laden;
And the Creole of Cuba laughs out to behold
Through orange-leaves shining the broad spheres of gold;
Yet with dearer delight from his home in the North,
On the fields of his harvest the Yankee looks forth,
Where crook-necks are coiling and yellow fruit shines,
And the sun of September melts down on his vines.

Ah! on Thanksgiving day, when from East and from West,
From North and from South comes the pilgrim and guest;
When the gray-haired New Englander sees round his board
The old broken links of affection restored;
When the care-wearied man seeks his mother once more,
And the worn matron smiles where the girl smiled before;
What moistens the lip and what brightens the eye,
What calls back the past, like the rich Pumpkin pie?

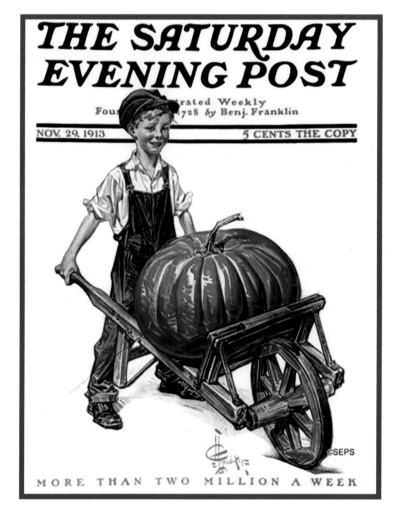

J. C. Leyendecker, *Saturday Evening Post* cover, November 29, 1913

Oh, fruit loved of boyhood! the old days recalling,
When wood-grapes were purpling and brown nuts were falling!
When wild, ugly faces we carved in its skin,
Glaring out through the dark with a candle within!
When we laughed round the corn-heap, with hearts all in tune,
Our chair a broad pumpkin,—our lantern the moon,
Telling tales of the fairy who travelled like steam
In a pumpkin-shell coach, with two rats for her team!

Then thanks for thy present! none sweeter or better
E'er smoked from an oven or circled a platter!
Fairer hands never wrought at a pastry more fine,
Brighter eyes never watched o'er its baking, than thine!
And the prayer, which my mouth is too full to express,
Swells my heart that thy shadow may never be less,
That the days of thy lot may be lengthened below,
And the fame of thy worth like a pumpkin-vine grow,
And thy life be as sweet, and its last sunset sky
Golden-tinted and fair as thy own Pumpkin pie!

—MATTHEW FRANKLIN WHITTIER (1812–1883)

*Piglet noticed that even though he had a Very Small Heart,
it could hold a rather large amount of Gratitude.*
—A. A. MILNE (1882–1956)

A POEM WRITTEN BY A STUDENT ON THE DAY HER SCHOOL CLOSED,
◆ MARCH 2020 ◆

Today I am grateful for Grandmas
For love, and cookies and wisdom
For years of knowledge and generosity
To health and life

Today I am grateful for spring
For warm weather, for rain and sun
For birds at the feeder
For four leaf clovers in the grass
Lighter jackets, lighter spirits
And for subconscious hope as the sun returns

Today I am grateful for school
For learning, and not for boredom
For routine, a sense of normalcy

Today I am grateful for things taken for granted
Like toilet paper and bread
But we'll make it through

Today I am grateful for my dog
Today I am grateful for my home
Today I am grateful I am young

And the beach and the wind
And those that I love who are safe and well
And clean clothes
And chickens

Today I am grateful for movies
For books and for friends
For crocuses and forsythia
For running in the morning
And making dinner in the evenings
And conversation, laughter, and honesty

And when I get afraid
For those that I love

I will remember
That there are good things happening
Positive, happy, beautiful things

And
I will remember
That today,
I am grateful

—ANONYMOUS

◆ EVERY CREATURE IS A WORD OF GOD ◆

—Meister Eckhart

Expectant, we process into
the pine forest with its architectural trees.
No candles, but between twigs
patches of Godlight fall
at our feet. In this arboreal cathedral
we are supplicants for grace, worshipers
of viridian words being
spoken into the air every hour
like music.

Silence like a stilled bell—
this is also a word.

Incense lifts
from pine needles underfoot.

And look there—an ant with his
thready waist, blessing God
that he is small and black and
has a crumb to carry.

Two squirrels, fleet as furred angels,
chase and chatter.

We listen for a bird choir, something
a cappella. But in a small pond's lap
a frog with gold eyes coughs twice
in praise of water threaded with reeds
gleaming like a sung psalm.

—LUCI SHAW (1928–), *The Generosity*

II
THE GARDENERS
WHO MAKE OUR SOULS
BLOSSOM

Gratitude for the Saints among Us

Let us be grateful
to the people who make us happy;
they are the charming gardeners
who make our souls blossom.
—MARCEL PROUST (1871–1922)

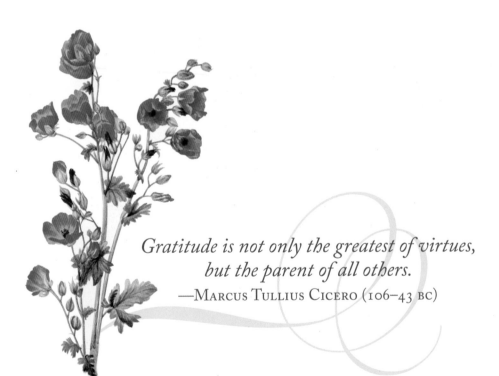

Gratitude is not only the greatest of virtues,
but the parent of all others.
—MARCUS TULLIUS CICERO (106–43 BC)

TO GENERAL VON WEBER,
◆ BERLIN ◆

Frankfort, 24th May, 1847

Even in the depth of my grief your letter has done me good. Your very handwriting first and your nearness to me at this moment is helpful, and then so also is every single word you write. Take my thanks for it, dear and faithful friend. Truly, one who has ever known my sister can never again forget her in a lifetime. But to us, and perhaps most of all to myself, to whom she was present with all her sweetness and affection at every moment, who could have no joy alone but only with the thought of her partaking in it, whom she from the first so helped and spoiled with all the richness of her sisterly love, and who always dreamed that this could never fail, it is a loss which we cannot yet measure at all, and even now I cannot help instinctively believing that our sorrow will be suddenly revoked. Yet I know it is all true, and the certainty is there, but now I cannot accustom myself to it, nor ever shall. It is beautiful to think of that noble, harmonious being, and how she is freed from the weariness of age and the decline of life, but it is hard for us to go on our way with true humility and endurance.

Pardon me that I can write so little, but, thank you, I must. My family are well, their happy children's faces with the unbroken gladness on them, are what has done me good in these days. I cannot think of music; if I turn my thoughts to it, it all seems waste and hollow. But when my children come in, a brightness comes with them, and then I can listen to them and watch them for hours.

The best of thanks for your letter. Heaven keep you and yours.

—FELIX MENDELSSOHN (1809–1847)

Joseph Stella (1877–1946), *Apotheosis of the Rose*

Be happy, noble heart, be blessed for all the good thou hast done and wilt do hereafter, and let my gratitude remain in obscurity like your good deeds.

—ALEXANDER DUMAS (1802–1870), *The Count of Monte Cristo*

We use "for" to introduce the reason for gratitude, and when we do so, "for" implies that someone else has been involved in or is responsible for the action: "We were grateful for the fruit" entails somebody else having provided it. . . .

Gratitude includes accepting—not resenting—dependence on something provided by someone who is not ourselves. It means concentrating on that person and on her kind intentions, just as she has concentrated her attention on me.

—MARGARET VISSER (1940–), *The Gift of Thanks*,
QUOTED IN JANA REISS (1969–), *Flunking Sainthood Every Day*

◆ ALMS MINISTRY ◆

Today at our church Alms Ministry, we saw nineteen people. They come to St. Paul's for any kind of help we can offer. . . .

One week two brothers come together. We ask them to sit down with us so we can hear their story. One, the deaf one, can drive. The other, too weak to speak for himself, is scheduled for a heart operation in Seattle later in the week. They have an ancient Chevy but no money for gas. We give them a voucher for thirty dollars made out to the local gas station.

The relief on their faces, even tears! The driver sobs, looking at us and hugging his brother, "Thank you. He's all I've got." Fuel for a car, even an old, beat-up vehicle, is like the living soul in an aged body. It speaks of freedom, of forward momentum, of release, of hope, of possibility.

—Luci Shaw (1928–), *Adventure of Ascent*,
quoted in Jana Reiss (1969–), *Flunking Sainthood Every Day*

54

For me, every hour is grace.
And I feel gratitude in my heart each time
I can meet someone and look at his or her smile.
—Elie Wiesel (1928–2016)

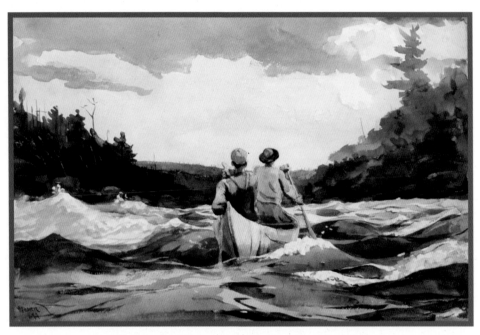

Winslow Homer (1836–1910), *Canoe in the Rapids*

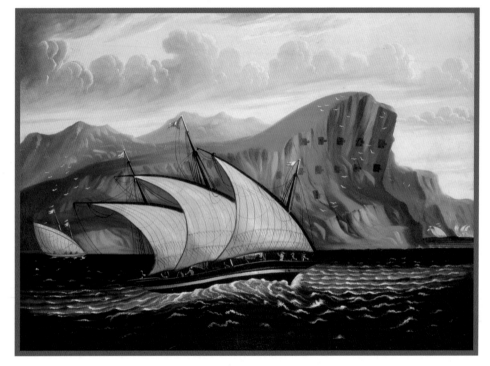

Thomas Chambers (1808–1869), *Felucca off Gibraltar*

Man is fond of reckoning up his troubles,
but does not count his joys.
If he counted them up as he ought,
he would see that every lot
has enough happiness provided for it.
—FYODOR DOSTOYEVSKY (1821–1881), *Notes from the Underground*

◆ KINDNESS REPAID IN GRATITUDE ◆

It happened in the old days at Rome that a slave named Androcles escaped from his master and fled into the forest, and he wandered there for a long time till he was weary and well nigh spent with hunger and despair. Just then he heard a lion near him moaning and groaning and at times roaring terribly. Tired as he was Androcles rose up and rushed away, as he thought, from the lion; but as he made his way through the bushes he stumbled over the root of a tree and fell down lamed, and when he tried to get up there he saw the lion coming towards him, limping on three feet and holding his fore-paw in front of him.

Poor Androcles was in despair; he had not strength to rise and run away, and there was the lion coming upon him. But when the great beast came up to him instead of attacking him it kept on moaning and groaning and looking at Androcles, who saw that the lion was holding out his right paw, which was covered with blood and much swollen. Looking more closely at it Androcles saw a great big thorn pressed into the paw, which was the cause of all the lion's trouble. Plucking up courage he seized hold of the thorn and drew it out of the lion's paw, who roared with pain when the thorn came out, but soon after found such relief from it that he fawned upon Androcles and showed, in every way that he knew, to whom he owed the relief. Instead of eating him up he brought him a young deer that he had slain, and Androcles managed to make a meal from it. For some time the lion continued to bring the game he had killed to Androcles, who became quite fond of the huge beast.

But one day a number of soldiers came marching through the forest and found Androcles, and as he could not explain what he was doing they took him prisoner and brought him back to the town from which he had fled.

Rosa Bonheur (1822–1899), *The Lion at Home*

Here his master soon found him and brought him before the authorities, and he was condemned to death because he had fled from his master. Now it used to be the custom to throw murderers and other criminals to the lions in a huge circus, so that while the criminals were punished the public could enjoy the spectacle of a combat between them and the wild beasts.

So Androcles was condemned to be thrown to the lions, and on the appointed day he was led forth into the Arena and left there alone with only a spear to protect him from the lion. The Emperor was in the royal box that day and gave the signal for the lion to come out and attack Androcles. But when it came out of its cage and got near Androcles, what do you think it did? Instead of jumping upon him it fawned upon him and stroked him with its paw and made no attempt to do him any harm.

It was of course the lion which Androcles had met in the forest. The Emperor, surprised at seeing such a strange behaviour in so cruel a beast, summoned Androcles to him and asked him how it happened that this particular lion had lost all its cruelty of disposition. So Androcles told the Emperor all that had happened to him and how the lion was showing its gratitude for his having relieved it of the thorn. Thereupon the Emperor pardoned Androcles and ordered his master to set him free, while the lion was taken back into the forest and let loose to enjoy liberty once more.

—AS TOLD BY JOSEPH JACOBS (1854–1916)

Gratitude, warm, sincere, intense,
when it takes possession of the bosom,
fills the soul to overflowing and
scarce leaves room for any other sentiment or thought.
—JOHN QUINCY ADAMS (1767–1848)

As we express our gratitude,
we must never forget
that the highest appreciation
is not to utter words,
but to live by them.
—JOHN F. KENNEDY (1917–1963)

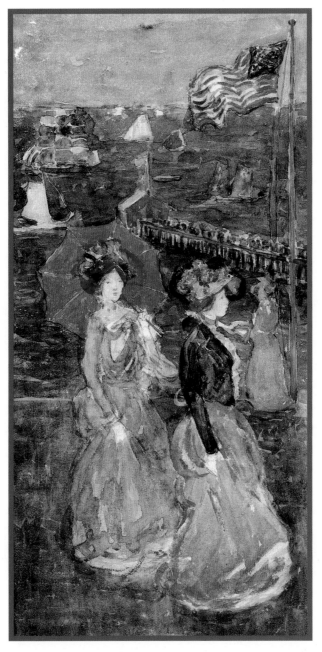

61

Maurice Prendergast (1858–1924), *Figures under the Flag*

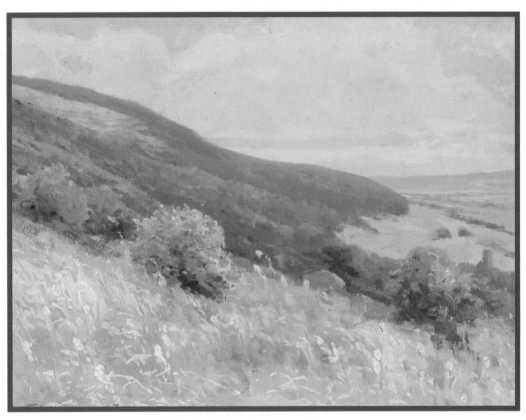

Csordák Lajos (1864–1937), *Landscape*

*The power of finding beauty in the humblest things
makes home happy and life lovely.*
—Louisa May Alcott (1832–1888)

◆ THE EVENING WIND ◆

Spirit that breathest through my lattice, thou
That cool'st the twilight of the sultry day,
Gratefully flows thy freshness round my brow:
Thou hast been out upon the deep at play,
Riding all day the wild blue waves till now,
Roughening their crests, and scattering high their spray
And swelling the white sail. I welcome thee
To the scorched land, thou wanderer of the sea!

Nor I alone—a thousand blossoms round
Inhale thee in the fulness of delight;
And languid forms rise up, and pulses bound
Livelier, at coming of the wind of night;
And, languishing to hear thy grateful sound,
Lies the vast inland stretched beyond the sight.
Go forth into the gathering shade; go forth,
God's blessing breathed upon the fainting earth!

Go, rock the little wood-bird in his nest,
Curl the still waters, bright with stars, and rouse
The wide old wood from his majestic rest,
Summoning from the innumerable boughs
The strange, deep harmonies that haunt his breast:
Pleasant shall be thy way where meekly bows.
The shutting flower, and darkling waters pass,
And where the o'ershadowing branches sweep the grass.

The faint old man shall lean his silver head
To feel thee; thou shalt kiss the child asleep,
And dry the moistened curls that overspread
His temples, while his breathing grows more deep:
And they who stand about the sick man's bed,
Shall joy to listen to thy distant sweep,
And softly part his curtains to allow
Thy visit, grateful to his burning brow.

Go—but the circle of eternal change,
Which is the life of nature, shall restore,
With sounds and scents from all thy mighty range
Thee to thy birthplace of the deep once more;
Sweet odours in the sea-air, sweet and strange,
Shall tell the home-sick mariner of the shore;
And, listening to thy murmur, he shall deem
He hears the rustling leaf and running stream.

—WILLIAM CULLEN BRYANT (1794–1878)

*I awoke this morning with devout thanksgiving
for my friends, the old and the new.*
—RALPH WALDO EMERSON (1803–1882)

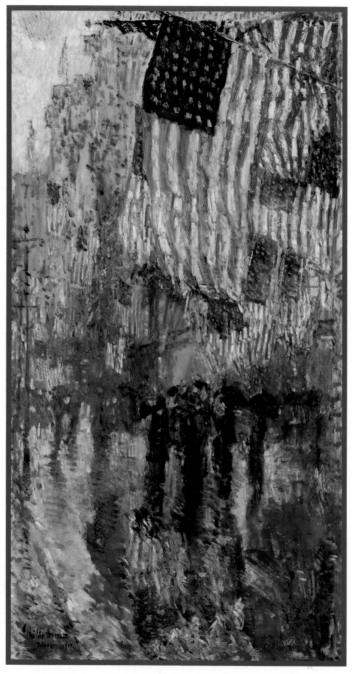

Childe Hassam (1859–1935), *The Avenue in the Rain*

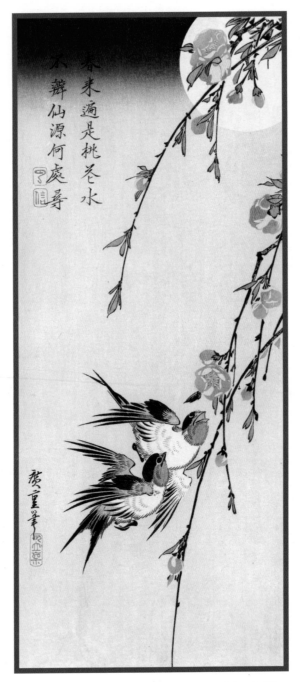

Hiroshige (1797–1858), *Moon Swallows and Peach Blossoms*

We should turn to St. Francis, in the spirit of thanks for what he has done. He was above all things a great giver; and he cared chiefly for the best kind of giving which is called thanksgiving. If another great man wrote a grammar of assent, he may well be said to have written a grammar of acceptance; a grammar of gratitude. He understood down to its very depths the theory of thanks; and its depths are a bottomless abyss. He knew that the praise of God stands on its strongest ground when it stands on nothing. He knew that we can best measure the towering miracle of the mere fact of existence if we realise that but for some strange mercy we should not even exist. And something of that larger truth is repeated in a lesser form in our own relations with so mighty a maker of history. He also is a giver of things we could not have even thought of for ourselves; he also is too great for anything but gratitude. From him came a whole awakening of the world and a dawn in which all shapes and colours could be seen anew.

67

The mighty men of genius who made the Christian civilisation that we know appear in history almost as his servants and imitators. Before Dante was, he had given poetry to Italy; before St. Louis ruled, he had risen as the tribune of the poor; and before Giotto had painted the pictures, he had enacted the scenes. That great painter who began the whole human inspiration of European painting had himself gone to St. Francis to be inspired. It is said that when St. Francis staged in his own simple fashion a Nativity Play of Bethlehem, with kings and angels in the stiff and gay medieval garments and the golden wigs that stood for haloes, a miracle was wrought full of the Franciscan glory. The Holy Child was a wooden doll or bambino, and it was said that he embraced it and that the image came to life in his arms. He assuredly was not thinking

of lesser things; but we may at least say that one thing came to life in his arms; and that was the thing that we call the drama. Save for his intense individual love of song, he did not perhaps himself embody this spirit in any of these arts. He was the spirit that was embodied. He was the spiritual essence and substance that walked the world, before anyone had seen these things in visible forms derived from it: a wandering fire as if from nowhere, at which men more material could light both torches and tapers. He was the soul of medieval civilisation before it even found a body.

—G. K. CHESTERTON (1874–1936)

68

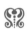

Giotto (c. 1267–1337), *St. Francis Preaching to the Birds*

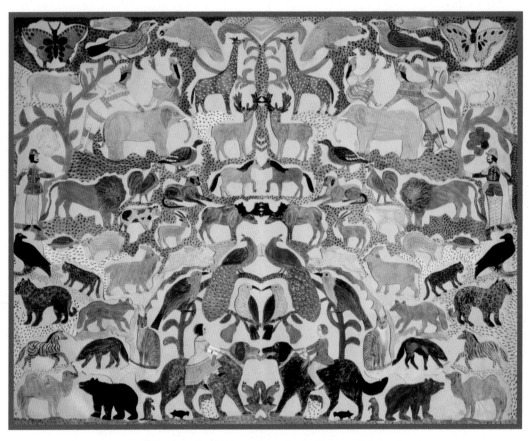

Nineteenth-Century American, *Cutout of Animals*

*No one who achieves success does so
without acknowledging the help of others.
The wise and confident acknowledge this help
with gratitude.*
—ALFRED NORTH WHITEHEAD (1861–1947)

Gratitude begins in our hearts and then dovetails into behavior. It almost always makes you willing to be of service, which is where the joy resides. It means you are willing to stop being such a jerk. When you are aware of all that has been given to you, in your lifetime and in the past few days, it is hard not to be humbled, and pleased to give back.

—ANNE LAMOTT (1954–), *Help Thanks Wow*,
QUOTED IN JANA REISS (1968–), *Flunking Sainthood Every Day*

71

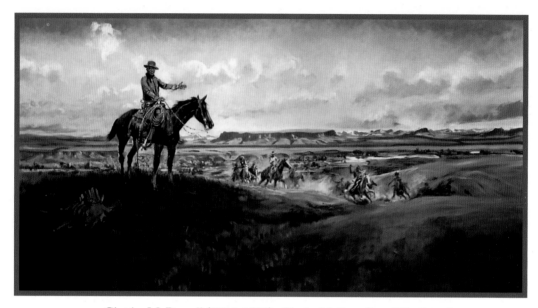

Charles M. Russell (1864–1926), *Charles M. Russell and His Friends*

Gratitude is the sign of noble souls.
—Aesop (c. 620–564 bc)

THE MANY PEOPLE WHO HAVE URGED
◆ ME ON AND HELPED ME LEARN ◆

My poor schoolmistress wanted to finish her year of school: she departed only three days before the end of the lessons. Day after to-morrow we go once more to the schoolroom to hear the reading of the monthly story, *The Shipwreck*, and then—it is over. On Saturday, the first of July, the examinations begin. And then another year, the fourth, is past! If my mistress had not died, it would have passed well.

I thought over all that I had known on the preceding October, and it seems to me that I know a good deal more: I have so many new things in my mind. I can say and write what I think better than I could then; I can also do the sums of many grown-up men who know nothing about it, and help them in their affairs. I understand much more: I remember nearly everything that I read. I am satisfied.

But how many people have urged me on and helped me learn, one in one way, and another in another, at home, at school, in the street, everywhere where I have been and where I have seen anything! And now I thank you all.

I thank you first, my good teacher, for having been so indulgent and affectionate with me; for you every new acquisition of mine was a labor, for which I now rejoice and of which I am proud. I thank you, Derossi, my admirable friend, for your prompt and kind explanations, for you have made me understand many of the most difficult things, and overcome stumbling-blocks at examinations; and you, too, Stardi, you brave and strong boy, who have showed me how a will of iron succeeds in everything; and you, kind, good Garrone, who make all those who know you kind and good too; and you too, Precossi and Coretti, who have given me an

example of courage in suffering, and of serenity in toil. I return thanks to you, and thanks to all the rest.

But above all, I thank you, my father, my first teacher, my first friend, who have given me so many wise counsels, and taught me so many things, while you were working for me, always concealing your sadness from me, and seeking in all ways to render study easy, and life beautiful to me; and you, sweet mother, my beloved and blessed guardian angel, who have tasted all my joys, and suffered all my bitternesses, who have studied, worked, and wept with me, with one hand on my brow, and with the other pointing me to Heaven. I kneel before you, as when I was a little child; I thank you for all the tenderness which you have instilled into my mind through twelve years of sacrifices and love.

—Edmondo De Amicis (1846–1908)
Trans. Isabel Florence Hapgood (1851–1928)
(From *Heart: A Schoolboy's Journal*)

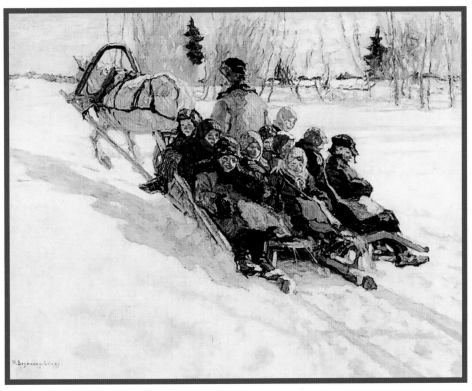

Nikolay Bogdanov-Belsky (1868–1945), *To School*

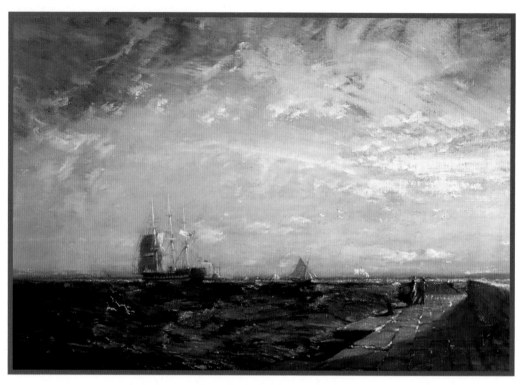

James Campbell Noble (1845–1913), *Outward Bound*

*It isn't what you have or who you are or where you are
or what you are doing that makes you happy or unhappy.
It is what you think about it.*
—DALE CARNEGIE (1888–1955)

*I can no other answer make but thanks,
And thanks; and ever thanks.*
—WILLIAM SHAKESPEARE (1564–1616), *Twelfth Night*

◆ LIFE ◆

Life, believe, is not a dream
So dark as sages say;
Oft a little morning rain
Foretells a pleasant day.
Sometimes there are clouds of gloom,
But these are transient all;
If the shower will make the roses bloom,
O why lament its fall?
Rapidly, merrily,
Life's sunny hours flit by,
Gratefully, cheerily
Enjoy them as they fly!
What though Death at times steps in,
And calls our Best away?
What though sorrow seems to win,
O'er hope, a heavy sway?
Yet Hope again elastic springs,
Unconquered, though she fell;
Still buoyant are her golden wings,
Still strong to bear us well.
Manfully, fearlessly,
The day of trial bear,
For gloriously, victoriously,
Can courage quell despair!

—CHARLOTTE BRONTË (1816–1855)

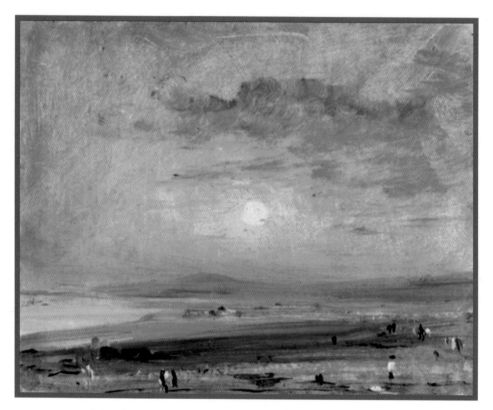

John Constable (1776–1837), *Shoreham Bay, Evening Sunset*

Reflect upon your present blessings—
of which every man has many—
not on your past misfortunes,
of which all men have some.
—CHARLES DICKENS (1812–1870), *Sketches by Boz*

A BEAUTIFUL THOUGHT
♦ IS A THING DIVINE ♦

I thank thee, friend, for the beautiful thought
That in words well chosen thou gavest to me,
Deep in the life of my soul it has wrought
With its own rare essence to ever imbue me,
To gleam like a star over devious ways,
To bloom like a flower on the dreariest days
Better such gift from thee to me
Than gold of the hills or pearls of the sea.

For the luster of jewels and gold may depart,
And they have in them no life of the giver,
But this gracious gift from thy heart to my heart
Shall witness to me of thy love forever;
Yea, it shall always abide with me
As a part of my immortality;
For a beautiful thought is a thing divine,
So I thank thee, oh, friend, for this gift of thine.

—LUCY MAUD MONTGOMERY (1874–1942)

*Out of suffering comes the serious mind; out of salvation,
the grateful heart; out of endurance, fortitude; out of
deliverance faith. Patient endurance attends to all things.*
—TERESA OF AVILA (1515–1582)

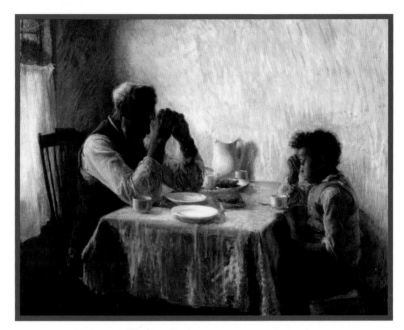

Henry Tanner (1859–1937), *The Thankful Poor*

There are only two ways to live your life.
One is as though nothing is a miracle.
The other is as though everything is a miracle.
—ATTRIBUTED TO ALBERT EINSTEIN (1879–1955)

FAREWELL ADDRESS OF
◆ GEORGE WASHINGTON ◆

In looking forward to the moment, which is intended to terminate the career of my public life, my feelings do not permit me to suspend the deep acknowledgment of that debt of gratitude, which I owe to my beloved country for the many honors it has conferred upon me; still more for the steadfast confidence with which it has supported me; and for the opportunities I have thence enjoyed of manifesting my inviolable attachment, by services faithful and persevering, though in usefulness unequal to my zeal. If benefits have resulted to our country from these services, let it always be remembered to your praise, and as an instructive example in our annals, that under circumstances in which the passions, agitated in every direction, were liable to mislead, amidst appearances sometimes dubious, vicissitudes of fortune often discouraging, in situations in which not unfrequently want of success has countenanced the spirit of criticism, the constancy of your support was the essential prop of the efforts, and a guarantee of the plans by which they were effected. Profoundly penetrated with this idea, I shall carry it with me to my grave, as a strong incitement to unceasing vows that Heaven may continue to you the choicest tokens of its beneficence; that your union and brotherly affection may be perpetual; that the free constitution, which is the work of your hands, may be sacredly maintained; that its administration in every department may be stamped with wisdom and virtue; that, in fine, the happiness of the people of these States, under the auspices of liberty, may be made complete, by so careful a preservation and so prudent a use of this blessing, as will acquire to them the glory of recommending it to the applause, the affection, and adoption of every nation, which is yet a stranger to it.

—GEORGE WASHINGTON (1732–1799)

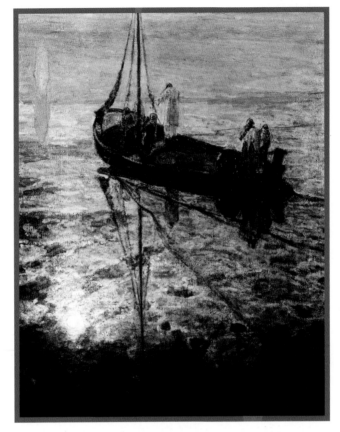

Henry Tanner (1859–1937), *The Disciples See Christ Walking on the Water*

There is no better way to thank God for your sight than by giving a helping hand to someone in the dark.
—HELEN KELLER (1880–1968)

It's a father's duty to give his sons a fine chance.
—George Eliot, *Middlemarch*

Today is Michael's birthday. He is my youngest son who was born on March 31, 1985, in the morning.

March 31 is the ninetieth day of the year. On this date in 1889 the Eiffel Tower in Paris was officially opened. In 1918 Daylight Savings Time went into effect for the first time. Johann Sebastian Bach was born on this day in 1685. The poet Octavio Paz was born on March 31, 1914. And March 31 was also my father's birthday, nice bookends to my life.

The Eiffel Tower is 1,063 feet tall. Michael is 5'11" and a fireman in Jersey City, New Jersey. He climbs a 100-foot ladder that leans against a building that is gushing smoke and fire.

In the summers when the days were longer and the sunlight brighter, I remember watching Michael racing throughout the neighborhood on his bike with his friends. I watched him on the swing. I watched him rush into the house delighted that it was spring. Michael is one of the daylight saving's gifts in my mind's eyes.

Bach created the glorious *Brandenburg Concertos*. When I hear Michael whistling, I hear a symphony in my heart.

In Octavio Paz's poem "Piedra de Sol" (Sun Stone), he wrote, "To love is to undress our names." Michael is a Hebrew name meaning "Who is like God." When I think of God I think about mercy, kindness, generosity . . . Michael's personality traits.

In the Bible the angel Michael fought Satan and became the patron saint of soldiers. I am Michael's best soldier in his army.

Fathers want to protect their sons. When Michael was a boy and we took him to the arcade at the Jersey shore, I ached each time he didn't win a plush dog or snake at the games. When I took him to Yankee Stadium and he brought his mitt, I ached that he didn't catch a fly ball. When Michael had surgery on his shoulder, when he tells me about a fire he helped extinguish, when I see the ugly side of the world in the news, I want to rush to Michael, grab him, and bring him home and protect him.

Atticus Finch in *To Kill a Mockingbird* felt the same about his son, Jem: "There's a lot of ugly things in this world, son. I wish I could keep 'em all away from you. That's never possible."

When I sit next to Michael I spontaneously smile. He is the type of person that lights up a room with his personality. When he beats me at chess (most of the time) I take delight in his clever moves.

Michael is a good son, a good husband to his wife Lauren, a good brother to Karen and David, a good colleague at the firehouse.

On his son's first day of school, Abraham Lincoln wrote a letter to the boy's teacher. "It is all going to be strange and new to him for a while and I wish you would treat him gently," the letter began, and then the sixteenth president asked the teacher to take good care of the child.

- Teach him that for every enemy, there is a friend.
- 10 cents earned is far better than a dollar found.
- It is far more honorable to fail than to cheat.
- Teach him to learn how to gracefully lose, and enjoy winning when he does win.
- Teach him to avoid envy and the secret of the quiet laughter.
- Teach him to laugh when he is sad.
- Teach him the wonders of books and to ponder the extreme mystery of birds in the sky.

- Teach him to have faith in his own idea.
- Try to teach my son the strength not to follow the crowd.
- Let him have the courage to be impatient and the courage to be brave.
- Teach him to have sublime faith in himself, because then he will always have sublime faith in mankind, in God.

These are the things that the father wished for his son. Lincoln ended the letter with these simple words: "See what you can do. He is such a nice little boy, and he is my son."

—CHRIS DE VINCK (1951–), *Things That Matter Most*

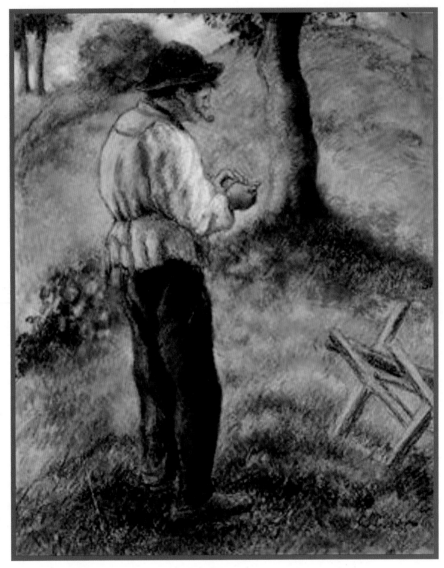

Camille Pissarro (1830–1903), *Father Melon Lights His Pipe*

III

GRATITUDE IS
A DIVINE EMOTION

Giving Thanks to God

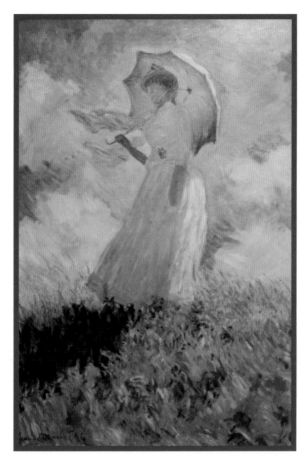

Claude Monet (1840–1926), *Study of a Figure Outdoors*

Do not spoil what you have by desiring what you have not;
remember that what you now have
was once among the things you only hoped for.
—EPICURUS (341–270 BC)

I THANK MY FATHER
◆ FOR HIS GIFTS TO ME ◆

Today let us be thankful. We have come to gentler pathways and to smoother roads. There is no thought of turning back, and no implacable resistance to the truth. A bit of wavering remains, some small objections and a little hesitance, but you can well be grateful for your gains, which are far greater than you realize.

A day devoted now to gratitude will add the benefit of some insight into the real extent of all the gains which you have made; the gifts you have received. Be glad today, in loving thankfulness, your Father has not left you to yourself, nor let you wander in the dark alone. Be grateful He has saved you from the self you thought you made to take the place of Him and His creation. Give Him thanks today.

Give thanks that He has not abandoned you, and that His Love forever will remain shining on you, forever without change. Give thanks as well that you are changeless, for the Son He loves is changeless as Himself. Be grateful you are saved. Be glad you have a function in salvation to fulfill. Be thankful that your value far transcends your meager gifts and petty judgments of the one whom God established as His Son.

Today in gratitude we lift our hearts above despair, and raise our thankful eyes, no longer looking downward to the dust. We sing the song of thankfulness today, in honor of the Self that God has willed to be our true Identity in Him. Today we smile on everyone we see, and walk with lightened footsteps as we go to do what is appointed us to do.

We do not go alone. And we give thanks that in our solitude a Friend has come to speak the saving Word of God to us. And thanks to you for listening to Him. His Word is soundless if it be not heard. In thanking

Him the thanks are yours as well. An unheard message will not save the world, however mighty be the Voice that speaks, however loving may the message be.

Thanks be to you who heard, for you become the messenger who brings His Voice with you, and lets It echo round and round the world. Receive the thanks of God today, as you give thanks to Him. For He would offer you the thanks you give, since He receives your gifts in loving gratitude, and gives them back a thousand and a hundred thousand more than they were given. He will bless your gifts by sharing them with you. And so they grow in power and in strength, until they fill the world with gladness and with gratitude.

Receive His thanks and offer yours to Him for fifteen minutes twice today. And you will realize to Whom you offer thanks, and Whom He thanks as you are thanking Him. This holy half an hour given Him will be returned to you in terms of years for every second; power to save the world eons more quickly for your thanks to Him.

Receive His thanks, and you will understand how lovingly He holds you in His Mind, how deep and limitless His care for you, how perfect is His gratitude to you. Remember hourly to think of Him, and give Him thanks for everything He gave His Son, that he might rise above the world, remembering his Father and his Self.

90

—HELEN SCHUCMAN (1909–1981),
A Course in Miracles: Workbook for Students, Lesson 123

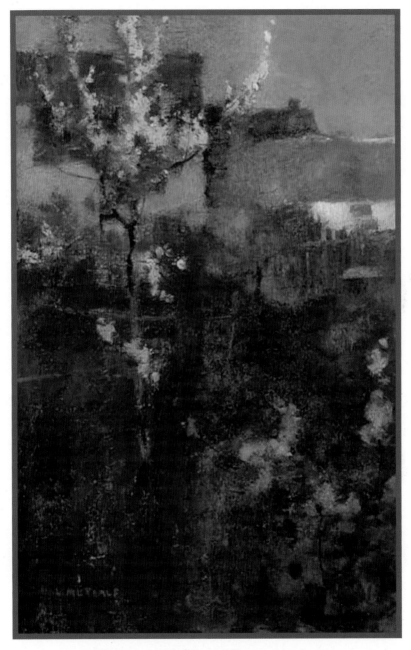

Willard Metcalf (1858–1925), *Remember Spring*

To be grateful is to recognize the love of God in everything He has given us—and He has given us everything. Every breath we draw is a gift of His love, every moment of existence is grace, for it brings with us immense graces from Him. Gratitude therefore takes nothing for granted, is never unresponsive, is constantly awakening to new wonder, and to praise of the goodness of God. For the grateful person knows that God is good, not by hearsay but by experience. And that is what makes all the difference.

—THOMAS MERTON (1915–1968), *Thoughts in Solitude*

To be a saint is to be fueled by gratitude,
nothing more and nothing less.
—RONALD ROLHEISER (1947–), *The Holy Longing*

IT IS NOT ENOUGH TO GIVE THANKS;
◆ ONE SHOULD BE THANK-FULL ◆

B ut in those days we all went to church before noon, to take care of our souls first, and in the afternoon we should take just as good care of our bodies. The sermon was twice as long as the prayer, which was half an hour by the feelings, there being no town clock and few watches. But our parson Chase gave us what was worth the while—yes, indeed! It was not a lot of wandering enthusiasms about Tolstoy, or Browning, or Ibsen. Bless the Lord, the realists were not in the world yet, and the transcendentalists were in their bibs. The sermon was a plain and right straightforward talk of duty and rightness. To this day I remember that very sermon. Said the good parson:

"It is not enough to give thanks; one should be thank-full—that is it— that is what the world means; full of thanks. And there are two more words like it; good, honest, worthy words of our fathers—faith-full and truth-full. These make the trinity of character. One should be full of faith, and truth, and gratitude. This a man fairly owes to God. Keep faith; speak truth; feel thanks. It is an excellent thing that one may be full of each; and not one of them crowd the other. Is it not a glad world that offers us such elements; such soul-food? No, you cannot make up for the lack of such things, by eating fine dinners of dainties. You shall hunger still; till your soul dies within you, and you be, what so many folk are, only outside shucks of men, and without soul-life at all. . . .

"And when you think of it, there is no better friend than God. The world is a good world. It is wonderfully gotten up for us; and if I thought that I should forget to be grateful to him, in whom we live and move and have our being, I should not wish to live. Thanksgiving Day is a jewel, to

set in the hearts of honest men; but be careful that you do not take the day, and leave out the gratitude. . . . Live lovingly; live peacefully; live nobly. . . . Now go to your homes; eat, drink, and be merry. . . . Feed your souls, as well as your bellies."

—EDWARD PAYSON POWELL (1833–1915),
An Old-Time Thanksgiving

The choice of gratitude rarely comes without some real effort. But each time I make it, the next choice is a little easier, a little freer, a little less self-conscious. Because every gift I acknowledge reveals another and another, until finally even the most normal, obvious, and seemingly mundane event or encounter proves to be filled with grace.

—HENRI J. M. NOUWEN (1932–1996),
The Return of the Prodigal Son

◆ GRATITUDE AND LOVE TO GOD ◆

All are indebted much to thee,
But I far more than all,
From many a deadly snare set free,
And raised from many a fall.
Overwhelm me, from above,
Daily, with thy boundless love.

What bonds of gratitude I feel
No language can declare;
Beneath the oppressive weight I reel,
'Tis more than I can bear:
When shall I that blessing prove,
To return thee love for love?

Spirit of charity, dispense
Thy grace to every heart;
Expel all other spirits thence,
Drive self from every part;
Charity divine, draw nigh,
Break the chains in which we lie!

All selfish souls, whate'er they feign,
Have still a slavish lot;
They boast of liberty in vain,
Of love, and feel it not.
He whose bosom glows with thee,
He, and he alone, is free.

Oh blessedness, all bliss above,
When thy pure fires prevail!
Love only teaches what is love:
All other lessons fail:
We learn its name, but not its powers,
Experience only makes it ours.

—WILLIAM COWPER (1731–1800)

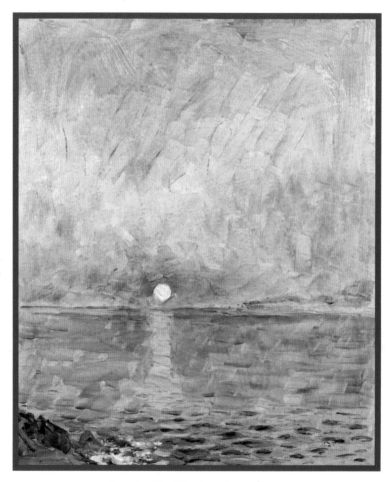

Dezider Czölder (1875–1933), *Sea*

When it comes to life the critical thing is whether you take things for granted or take them with gratitude.
—G. K. Chesterton (1874–1936)

GRATITUDE
◆ A POOR MAN'S VIRTUE IS ◆

If gratitude a poor man's virtue is,
'Tis one at least my sick soul can afford.
Bankrupt I am of all youth's charities,
But not of thanks. No. Thanks be to the Lord!
Praise be, dear Lady of all grace, to you.
You were my mediciner, my one sole friend,
When the world spurned me from its retinue.
And I am yours, your bond-slave to the end.
—How shall I tell it you? There was a time
When I was sordid in my unbelief,
And mocked at all things less robust than crime,
A convict in my prison-house of grief.
But that is past. Your pity was the key
Which sent me forth, a broken man, but free.

—Wilfrid Scawen Blunt (1840–1922)

If one should give me a dish of sand, and tell me there were particles of iron in it, I might look for them with my eyes, and search for them with my clumsy fingers, and be unable to detect them; but let me take a magnet and sweep through it, and how would it draw to itself the almost invisible particles by the mere power of attraction. The unthankful heart, like my finger in the sand, discovers no mercies; but let the thankful heart sweep through the day, and as the magnet finds the iron, so it will find, in every hour, some heavenly blessings; only the iron in God's sand is gold.

—HENRY WARD BEECHER (1813–1887)

WITHOUT GRATITUDE
◆ THERE IS NOUGHT ◆

Without this—there is nought—
All other Riches be
As is the Twitter of a Bird—
Heard opposite the Sea—

I could not care—to gain
A lesser than the Whole—
For did not this include themself—
As Seams—include the Ball?

I wished a way might be
My Heart to subdivide—
'Twould magnify—the Gratitude—
And not reduce—the Gold—

—Emily Dickinson (1830–1886)

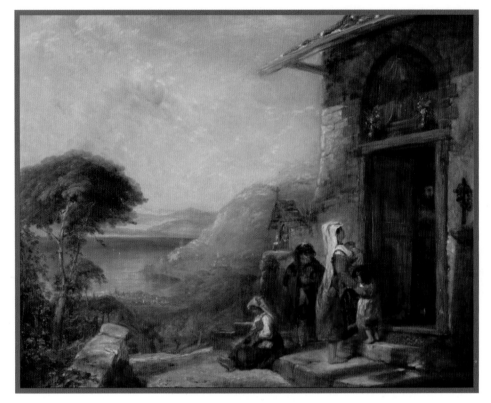

William Collins (1788–1847),
Poor Travellers at the Door of a Capuchin Convent near Vico, Bay of Naples

*If the only prayer you ever say
in your entire life is "thank you,"
it will be enough.*

—MEISTER ECKHART (C.1260–C.1328)

GIVE US A THANKFUL SENSE OF THE
◆ BLESSINGS IN WHICH WE LIVE ◆

Give us grace, Almighty Father, so to pray, as to deserve to be heard, to address thee with our Hearts, as with our lips. Thou art every where present, from Thee no secret can be hid. May the knowledge of this, teach us to fix our Thoughts on Thee, with Reverence and Devotion that we pray not in vain.

Look with Mercy on the Sins we have this day committed, and in Mercy make us feel them deeply, that our Repentance may be sincere, & our resolutions stedfast of endeavouring against the commission of such in future. . . .

Give us a thankful sense of the Blessings in which we live, of the many comforts of our lot; that we may not deserve to lose them by Discontent or Indifference.

Be gracious to our Necessities, and guard us, and all we love, from Evil this night. May the sick and afflicted, be now, and ever thy care; and heartily do we pray for the safety of all that travel by Land or by Sea, for the comfort & protection of the Orphan and Widow and that thy pity may be shewn upon all Captives and Prisoners.

Above all other blessings Oh! God, for ourselves, and our fellow-creatures, we implore Thee to quicken our sense of thy Mercy in the redemption of the World, of the Value of that Holy Religion in which we have been brought up, that we may not, by our own neglect, throw away the salvation thou hast given us, nor be Christians only in name. Hear us Almighty God, for His sake who has redeemed us, and taught us thus to pray.

—JANE AUSTEN (1775–1817)

You say grace before meals. All right. But I say grace before the concert and the opera, and grace before the play and pantomime, and grace before I open a book, and grace before sketching, painting, swimming, fencing, boxing, walking, playing, dancing, and grace before I dip the pen in the ink.

—G. K. CHESTERTON (1874–1936)

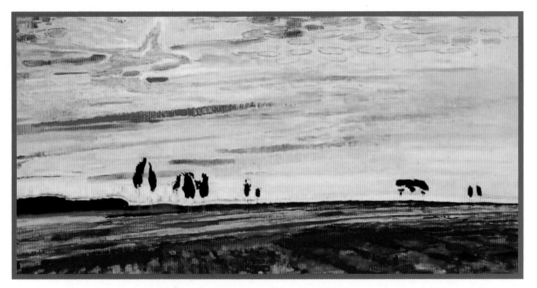

Jan Sluyters (1881–1957), *Morning Glory*

You pray in your distress and in your need;
would that you might pray also in the fullness of your joy
and in your days of abundance.

—KAHLIL GIBRAN (1883–1931), *The Prophet*

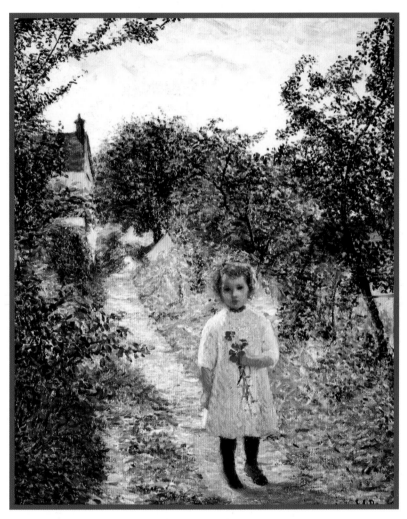

Lilla Cabot Perry (1848–1933), *Little Girl in a Lane*

NIGHT AND DAY MAY WE GIVE
◆ YOU PRAISE AND THANKS ◆

Be kind to your little children, Lord.

Be a gentle teacher, patient with our weakness and stupidity.

And give us the strength and discernment to do what you tell us,
 and so grow in your likeness.

May we all live in the peace that comes from you.

May we journey toward your city,
 sailing through the waters of sin untouched by the waves,
 borne serenely along by the Holy Spirit.

Night and day may we give you praise and thanks,
 because you have shown us that all things belong to you,
 and all blessings are gifts from you.

To you, the essence of wisdom, the foundation of truth,
 be glory for evermore.

—Clement of Alexandria (c. ad 150–c. 215)

LOVE IS THE WAY I WALK
◆ IN GRATITUDE ◆

Gratitude is a lesson hard to learn for those who look upon the world amiss. The most that they can do is see themselves as better off than others. And they try to be content because another seems to suffer more than they. How pitiful and deprecating are such thoughts! For who has cause for thanks while others have less cause? And who could suffer less because he sees another suffer more? Your gratitude is due to Him alone Who made all cause of sorrow disappear throughout the world.

It is insane to offer thanks because of suffering. But it is equally insane to fail in gratitude to One Who offers you the certain means whereby all pain is healed, and suffering replaced with laughter and with happiness. Nor could the even partly sane refuse to take the steps which He directs, and follow in the way He sets before them, to escape a prison that they thought contained no door to the deliverance they now perceive.

Your brother is your "enemy" because you see in him the rival for your peace; a plunderer who takes his joy from you, and leaves you nothing but a black despair so bitter and relentless that there is no hope remaining. Now is vengeance all there is to wish for. Now can you but try to bring him down to lie in death with you, as useless as yourself; as little left within his grasping fingers as in yours.

You do not offer God your gratitude because your brother is more slave than you, nor could you sanely be enraged if he seems freer. Love makes no comparisons. And gratitude can only be sincere if it be joined to love. We offer thanks to God our Father that in us all things will find their freedom. It will never be that some are loosed while others still are bound. For who can bargain in the name of love?

Therefore give thanks, but in sincerity. And let your gratitude make room for all who will escape with you; the sick, the weak, the needy and afraid, and those who mourn a seeming loss or feel apparent pain, who suffer cold or hunger, or who walk the way of hatred and the path of death. All these go with you. Let us not compare ourselves with them, for thus we split them off from our awareness of the unity we share with them, as they must share with us.

We thank our Father for one thing alone; that we are separate from no living thing, and therefore one with Him. And we rejoice that no exceptions ever can be made which would reduce our wholeness, nor impair or change our function to complete the One Who is Himself completion. We give thanks for every living thing, for otherwise we offer thanks for nothing, and we fail to recognize the gifts of God to us.

Walk, then, in gratitude the way of love. For hatred is forgotten when we lay comparisons aside. What more remains as obstacles to peace? The fear of God is now undone at last, and we forgive without comparing. Thus we cannot choose to overlook some things, and yet retain some other things still locked away as "sins." When your forgiveness is complete you will have total gratitude, for you will see that everything has earned the right to love by being loving, even as your Self.

Today we learn to think of gratitude in place of anger, malice, and revenge. We have been given everything. If we refuse to recognize it, we are not entitled therefore to our bitterness, and to a self-perception which regards us in a place of merciless pursuit, where we are badgered ceaselessly, and pushed about without a thought or care for us or for our future. Gratitude becomes the single thought we substitute for these insane perceptions. God has cared for us, and calls us Son. Can there be more than this?

Our gratitude will pave the way to Him, and shorten our learning time by more than you could ever dream of. Gratitude goes hand in hand with love, and where one is the other must be found. For gratitude is but an aspect of the Love which is the Source of all creation. God gives thanks to you, His Son, for being what you are; His Own completion and the Source of love, along with Him. Your gratitude to Him is one with His to you. For love can walk no road except the way of gratitude, and thus we go who walk the way to God.

—Helen Schucman (1909–1981),
A Course in Miracles: Workbook for Students, Lesson 195

Love of God is pure when joy and suffering
inspire an equal degree of gratitude.
—Simone Weil (1909–1943)

Ivan Kramskoy (1837–1887), *Children in the Forest*

Ilya Repin (1844–1930), *Blessing Children*

Prayer is sitting in the silence until it silences us,
choosing gratitude until we are grateful,
and praising God until we ourselves are an act of praise.
—RICHARD ROHR (1943-)

THANKSGIVING PROCLAMATION
◆ BY ABRAHAM LINCOLN ◆

The year that is drawing toward its close has been filled with the blessings of fruitful fields and healthful skies. To these bounties, which are so constantly enjoyed that we are prone to forget the source from which they come, others have been added, which are of so extraordinary a nature that they cannot fail to penetrate and even soften the heart which is habitually insensible to the ever-watchful providence of Almighty God.

In the midst of a civil war of unequaled magnitude and severity, which has sometimes seemed to foreign states to invite and provoke their aggressions, peace has been preserved with all nations, order has been maintained, the laws have been respected and obeyed, and harmony has prevailed everywhere, except in the theater of military conflict; while that theater has been greatly contracted by the advancing armies and navies of the Union.

Needful diversions of wealth and of strength from the fields of peaceful industry to the national defense have not arrested the plow, the shuttle, or the ship; the ax has enlarged the borders of our settlements, and the mines, as well of iron and coal as of the precious metals, have yielded even more abundantly than heretofore. Population has steadily increased, notwithstanding the waste that has been made in the camp, the siege, and the battlefield, and the country, rejoicing in the consciousness of augmented strength and vigor, is permitted to expect continuance of years with large increase of freedom.

No human counsel hath devised, nor hath any mortal hand worked out these great things. They are the gracious gifts of the Most High God, who while dealing with us in anger for our sins, hath nevertheless remembered mercy.

It has seemed to me fit and proper that they should be solemnly, reverently, and gratefully acknowledged as with one heart and one voice by the whole American people. I do, therefore, invite my fellow-citizens in every part of the United States, and also those who are at sea and those who are sojourning in foreign lands, to set apart and observe the last Thursday of November next as a Day of Thanksgiving and Praise to our beneficent Father who dwelleth in the heavens. And I recommend to them that, while offering up the ascriptions justly due to Him for such singular deliverances and blessings, they do also, with humble penitence for our national perverseness and disobedience, commend to His tender care all those who have become widows, orphans, mourners, or sufferers in the lamentable civil strife in which we are unavoidably engaged, and fervently implore the interposition of the Almighty hand to heal the wounds of the nation, and to restore it, as soon as may be consistent with the Divine purposes, to the full enjoyment of peace, harmony, tranquility, and union.

—ABRAHAM LINCOLN (1809–1865)

The best way to show my gratitude to God
is to accept everything, even my problems, with joy.
—MOTHER TERESA (1910–1997)

Hans Andersen Brendekilde (1857–1942), *Children Collecting Leftover Crops*

For my part,
I am almost contented just now,
and very thankful.
Gratitude is a divine emotion:
it fills the heart, but not to bursting;
it warms it, but not to fever.
—CHARLOTTE BRONTË (1816–1855)

IN YOUR LIGHT,
◆ I SEE THE LIGHT ◆

Thank you, Jesus, for bringing me this far.
In your light, I see the light of my life.

Your teaching is brief and to the point;
you persuade us to trust in God;
you command us to love one another.

114

You promise everything to those who obey your teaching;
you ask nothing too hard for a believer,
nothing a lover can refuse.

Your promises to your disciples are true, nothing but the truth.
Even more, you promise us yourself,
the perfection of all that can be made perfect.

—NICHOLAS OF CUSA (1401–1464)

O MY GOD, I THANK YOU
◆ AND I PRAISE YOU ◆

O my God, I thank you and I praise you for accomplishing your holy and all-lovable will without any regard for mine. With my whole heart, in spite of my heart, do I receive this cross I feared so much!

It is the cross of your choice, the cross of your love. I venerate it; nor for anything in the world would I wish that it had not come, since you willed it.

I keep it with gratitude and with joy, as I do everything that comes from your hand; and I shall strive to carry it without letting it drag, with all the respect and all the affection which your works deserve.

—FRANCIS DE SALES (1567–1622)

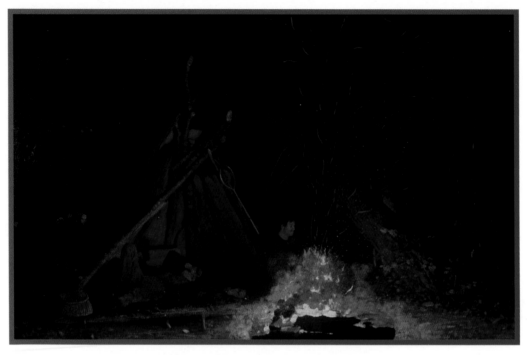

Winslow Homer (1836–1910), *Camp Fire*

I do not, in my private capacity, believe that a baby gets his best physical food by sucking his thumb; nor that a man gets his best moral food by sucking his soul, and denying its dependence on God or other good things. I would maintain that thanks are the highest form of thought; and that gratitude is happiness doubled by wonder.

—G. K. CHESTERTON (1874–1936), *A Short History of England*

IF ONLY I COULD GIVE YOU AS A
◆ GIFT TO EVERYTHING ALIVE ◆

If only it could all for once be so utterly still . . .
if the accidental and approximate
were silenced, together with the neighbor's laugh,
and if the noise my senses make
didn't hinder me so in waking,
then I could think You in a thousand-fold
thought all the way to Your bounds,
and own You—if only in the moment of a smile—
and thus give You as a gift to everything alive
like a word of thanks.

—RAINER MARIA RILKE (1875–1926),
Prayers of a Young Poet

A'TOIRT TAING
◆ (GIVING THANKS) ◆

Thanks to you, O God, that I have risen today,
To the rising of this life itself;
May it be to Your own glory, O God of every gift,
And to the glory of my soul likewise.

118

O great God, aid You my soul
With the aiding of Your own mercy;
Even as I clothe my body with wool,
Cover You my soul with the shadow of Your wing.

Help me to avoid every sin,
And the source of every sin to forsake;
And as the mist scatters on the crest of the hills,
May each ill haze clear from my soul, O God.

—*Ancient Celtic Blessing*, AS ADAPTED BY THOMAS McPHERSON

Edvard Munch (1863–1944), *The Sun*

Thankfulness is the tune of angels.
—EDMUND SPENSER (C. 1552–1599),
Dictionary of Burning Words of Brilliant Writers

HOW DO WE CULTIVATE
THE ATTITUDE OF GRATITUDE
◆ THAT LEADS TO JOY? ◆

120

How then, do we cultivate the attitude of gratitude that leads to joy in God? In addition to weekly participation in the Eucharist, we can give thanks in our daily prayers. When we kneel to pray our personal petitions, we can start a habit of beginning them with thanksgiving, even if just thanks that we are able to turn to God and pray at that moment. . . .

We can put our gratitude journals to good use, turning our lists of thanks into personal prayers. While there are many beautiful ones on the market, a simple notebook suffices. . . . When I sit down to fill my gratitude journal, I write what I am grateful for as a prayer that begins with "Thank you, God, for . . ." I have found that the structure of the Divine Liturgy gives me a three-part guide to help me go beyond counting my blessings to the thanksgiving that allows me to experience the giving and receiving of sacrificial love—and thus to experience joy.

—PHOEBE FARAG MIKHAIL (1978–), *Putting Joy into Practice*

The discipline of gratitude is the explicit effort to acknowledge that all I am and have is given to me as a gift of love, a gift to be celebrated with joy.
—HENRI J. M. NOUWEN (1932–1996)
The Dance of Life

◆ FLANNERY'S GRATITUDE ◆

*"My poor cousin has trouble but hers is arthritis—she can't
use her hands at all and is about bent double. After seeing
her, the lupus looks pretty good to me."*
 —Flannery O'Connor (1925–1964),
 September 13, 1956, *The Habit of Being*

The forms that grace takes far beyond my feeble
mind. *Such knowledge is too wonderful
for me*, the psalmist sings, and he is right.
This long disease, my life, Pope lamented
and I embrace, knowing no other way to live
without the body and blood that comes one's way.
Affliction is God's gift to give.
Who am I to refuse? And so I choose
my sickness. It's got my name on it,
and even better, my daddy's name too.
Long as I have my hands and my sight
I can work. I don't ask for length of days,
just enough to do what I was meant to.
Praise this world you put me in. Praise you.

—Angela Alaimo O'Donnell (1960–), *Andalusian Hours*

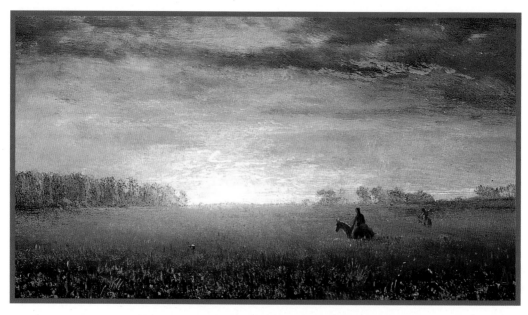

Albert Bierstadt (1930–1902), *Sunset of the Prairies*

I ARISE TODAY THROUGH A
◆ MIGHTY STRENGTH ◆

I arise today
Through a mighty strength:
God's power to guide me,
God's might to uphold me,
God's eyes to watch over me;
God's ear to hear me,
God's word to give me speech,
God's hand to guard me,
God's way to lie before me,
God's shield to shelter me,
God's host to secure me.

—BRIGID OF IRELAND (451–525)

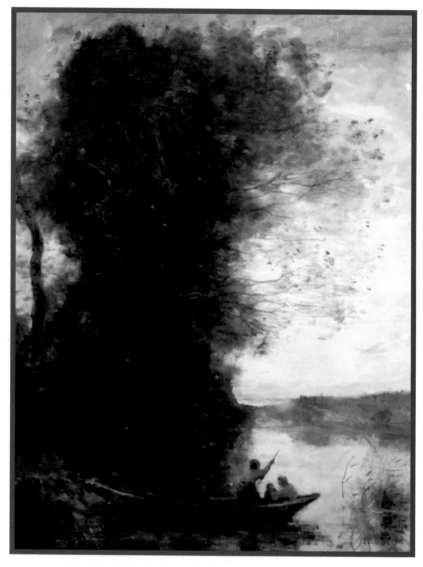

Camille Corot (1796–1875), *The Boatman Left the Bank
with a Woman and a Child Sitting in His Boat, Sunset*

THANKSGIVING PROCLAMATION
◆ 1815 BY JAMES MADISON ◆

The Senate and House of Representatives of the United States, have, by a joint Resolution, signified their desire, that a day may be recommended, to be observed by the people of the United States with religious solemnity, as a day of thanksgiving, and of devout acknowledgments to Almighty God, for His great goodness manifested in restoring to them, the blessing of peace.

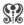

No people ought to feel greater obligations to celebrate the goodness of the Great Disposer of events, and of the destiny of nations, than the people of the United States. His kind Providence originally conducted them to one of the best portions of the dwelling place allotted for the great family of the Human race. He protected and cherished them, under all the difficulties and trials to which they were exposed in their early days. Under His fostering care, their habits, their sentiments, and their pursuits prepared them, for a transition in due time to a state of Independence and Self Government. In the arduous struggle by which it was attained, they were distinguished by multiplied tokens of His benign interposition. During the interval which succeeded, He reared them into the strength and endowed them with the resources, which have enabled them to assert their national rights, and to enhance their national character, in another arduous conflict, which is now so happily terminated, by a peace and reconciliation with those who have been our Enemies. And to the same Divine Author of every good and perfect gift, we are indebted for all those privileges and advantages, religious as well as civil, which are so richly enjoyed in this favored land.

Robert Havell Jr. (1793–1878), after John Audubon (1785–1851), *American Robins*

It is for blessings, such as these, and more especially for the restoration of the blessing of peace, that I now recommend, that the second Thursday in April next be set apart as a day on which the people of every religious denomination, may, in their solemn Assemblies, unite their hearts and their voices, in a free will offering to their Heavenly Benefactor, of their homage of thanksgiving, and of their songs of praise.

Given at the City of Washington on the fourth day of March in the year of our Lord one thousand eight hundred and fifteen, and of the Independence of the United States the thirty-ninth.

—JAMES MADISON (1751–1836)

Give us grateful hearts,
Our Father, for all thy mercies,
And make us mindful
Of the needs of others;
Through Jesus Christ our Lord.
Amen.

—BOOK OF COMMON PRAYER

Nicholas Roerich (1874–1947), *Warrior of Light*

◆ A THANKSGIVING POEM ◆

The sun hath shed its kindly light,
 Our harvesting is gladly o'er
Our fields have felt no killing blight,
 Our bins are filled with goodly store.

From pestilence, fire, flood, and sword
 We have been spared by thy decree,
And now with humble hearts, O Lord,
 We come to pay our thanks to thee.

We feel that had our merits been
 The measure of thy gifts to us,
We erring children, born of sin,
 Might not now be rejoicing thus.

No deed of ours hath brought us grace;
 When thou wert nigh our sight was dull,
We hid in trembling from thy face,
 But thou, O God, wert merciful.

Thy mighty hand o'er all the land
 Hath still been open to bestow
Those blessings which our wants demand
 From heaven, whence all blessings flow.

Thou hast, with ever watchful eye,
 Looked down on us with holy care,
And from thy storehouse in the sky
 Hast scattered plenty everywhere.

Then lift we up our songs of praise
 To thee, O Father, good and kind;
To thee we consecrate our days;
 Be thine the temple of each mind.

With incense sweet our thanks ascend;
 Before thy works our powers pall;
Though we should strive years without end,
 We could not thank thee for them all.

—PAUL LAURENCE DUNBAR (1872–1906)

◆ COUNT YOUR BLESSINGS ◆

When upon life's billows you are tempest tossed,
When you are discouraged, thinking all is lost,
Count your many blessings, name them one by one,
And it will surprise you what the Lord hath done.

Count your blessings, name them one by one;
Count your blessings, see what God hath done;
Count your blessings, name them one by one;
Count your many blessings, see what God hath done.

Are you ever burdened with a load of care?
Does the cross seem heavy you are called to bear?
Count your many blessings, ev'ry doubt will fly,
And you will be singing as the days go by.

When you look at others with their lands and gold,
Think that Christ has promised you His wealth untold;
Count your many blessings, money cannot buy
Your reward in heaven, nor your home on high.

So, amid the conflict, whether great or small,
Do not be discouraged, God is over all;
Count your many blessings, angels will attend,
Help and comfort give you to your journey's end.

Count your blessings, name them one by one;
Count your blessings, see what God hath done;
Count your blessings, name them one by one;
Count your many blessings, see what God hath done.

—JOHNSON OATMAN JR. (1856–1922)

◆ GOD'S GRANDEUR ◆

The world is charged with the grandeur of God.
 It will flame out, like shining from shook foil;
 It gathers to a greatness, like the ooze of oil
Crushed. Why do men then now not reck his rod?
Generations have trod, have trod, have trod;
 And all is seared with trade; bleared, smeared with toil;
 And wears man's smudge and shares man's smell: the soil
Is bare now, nor can foot feel, being shod.

And for all this, nature is never spent;
 There lives the dearest freshness deep down things;
And though the last lights off the black West went
 Oh, morning, at the brown brink eastward, springs —
Because the Holy Ghost over the bent
 World broods with warm breast and with ah! bright wings.

—GERARD MANLEY HOPKINS (1844–1889)

*For these blessings we owe to Almighty God,
from whom we derive them, and with profound reverence,
our most grateful and unceasing acknowledgments.*
—JAMES MONROE (1758–1831),
Eighth State of the Union Address, 1824

Odilon Redon (1840–1916), *Sacred Heart*

Mikhail Nesterov (1862–1942), *Christ Blesses Bartholomew*

LORD, HEAR AS WE SING
◆ BEFORE THY THRONE ◆

Lord, Who hast made us for thine own,
Hear as we sing before Thy throne. Alleluia.

Accept Thy children's rev'rent praise
For all Thy wondrous works and ways. Alleluia.

Waves, rolling in on ev'ry shore,
Pause at His footfall and adore. Alleluia.

Ye torrents rushing from the hills,
Bless Him Whose hand your fountains fills. Alleluia.

Earth, ever through the pow'r divine,
Seedtime and harvest shall be thine. Alleluia.

Sweet flow'rs that perfume all the air,
Thank Him that He hath made you fair. Alleluia.

Burn lamps of night, with constant flame,
Shine to the honour of His name. Alleluia.

Thou sun, whom all the lands obey,
Renew his praise from day to day. Alleluia.

—PARAPHRASE OF PSALM 148

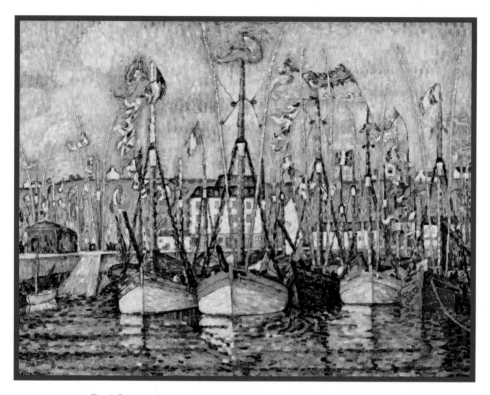

Paul Signac (1863–1935), *Blessing of the Tuna Fleet at Groix*

LIVING AS THOSE MADE
◆ ALIVE IN CHRIST ◆

Therefore, as God's chosen people, holy and dearly loved, clothe yourselves with compassion, kindness, humility, gentleness and patience. Bear with each other and forgive one another if any of you has a grievance against someone. Forgive as the Lord forgave you. And over all these virtues put on love, which binds them all together in perfect unity.

Let the peace of Christ rule in your hearts, since as members of one body you were called to peace. And be thankful. Let the message of Christ dwell among you richly as you teach and admonish one another with all wisdom through psalms, hymns, and songs from the Spirit, singing to God with gratitude in your hearts. And whatever you do, whether in word or deed, do it all in the name of the Lord Jesus, giving thanks to God the Father through him.

—COLOSSIANS 3:12–17, NIV

ALL LANDS SUMMONED
◆ TO PRAISE GOD ◆

Make a joyful noise to the LORD, all the lands!
 Serve the LORD with gladness!
 Come into his presence with singing!

138

Know that the LORD is God!
 It is he that made us, and we are his;
 we are his people, and the sheep of his pasture.

Enter his gates with thanksgiving,
 and his courts with praise!
 Give thanks to him, bless his name!

For the LORD is good;
 his steadfast love endures for ever,
 and his faithfulness to all generations.

—PSALM 100, RSV

GRATITUDE IS THE MEMORY
◆ OF THE HEART ◆

The eighteenth-century French clergyman and revolutionary Jean-Baptiste Massieu famously said, *La reconnaissance est la mémoire du cœur* ("Gratitude is the memory of the heart"). *Reconnaissance* has the sense of recognizing or literally "reknowing." That recognition, "reknowing," and gratitude are forged with *daily reflection and mindful awareness*. One of my spiritual directees spends ten minutes a day reflecting upon her life and remembering the many ways God has blessed her. Sometimes she surveys the broad strokes of her fifty years of life; other times she sits in gratitude and praise for a surprise visit from a friend, a sunny day, or a freshly brewed cup of coffee. She continually tells me that daily reflection and mindful awareness help to expand her heart as she comes to see the utter gratuity of the marvelous and the mundane.

The Jewish theologian Abraham Joshua Heschel once walked into his New York classroom and announced, "An incredible thing happened as I was walking over here to class." This comment piqued the curiosity of his students, who asked what he'd seen. Heschel responded, "The sun set. The sun set and no one on Broadway noticed it."

Heschel reminds us of the importance of *wonder and awe*. When we take the time to reflect not only on our life's journey but also on life itself, we get a sense of the magic in the air. And that drives us to our knees in thanks. The fingernails of a newborn baby, a shooting star streaking across the sky, the oddity of a Venus fly trap, the howling of a coyote, and the beauty of the Alps pull us out of ourselves and reveal something bigger than ourselves. And that "something" is a Creator who is enthusiastic about being in a relationship with us.

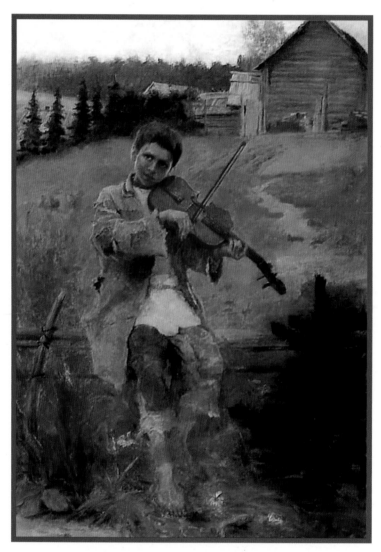

Nikolay Bogdanov-Belsky (1868–1945), *Boy with Violin*

The magnificent creativity of God and our awe at the lavishness of life lead us to an awareness of who we really are. Knowing that we are invited guests to the banquet of life fuels the virtue of *humility* that grounds all gratitude. Derived from the Latin word *humus*, meaning dirt or ground, humility keeps our feet on the ground as it raises up our eyes to God in thanks and praise. There is no authentic gratitude without the awareness of our unworthiness and insignificance.

Living in a world of progress reports, report cards, and performance evaluations, we are often tempted to take ourselves too seriously. What would it feel like to rediscover a childlike sense of *joy and playfulness* that connects you to the inherent goodness of life? A game of pitch-and-catch with an eight-year-old son? Playing house with a niece? Making up a bedtime story, walking the dog, finding a coworker to play Rock-Paper-Scissors, going for a swim, or dressing up with hat and boots and square dancing with a spouse? These activities can be spiritual practices that open us to a dimension of life that we, as adults, don't often experience. Far from a cynical question, "Are we having fun yet?" is an excellent reminder of the importance of joy and laughter. The mystic and saint Teresa of Avila rightly reminded her community that a sad nun is a bad nun. We grow old and ungrateful when we stop playing, teasing, and laughing.

Gratitude and appreciation form the warp and weft of every invited guest's clothing. They are so basic and essential for our spiritual transformation that Meister Eckhart, a fourteenth-century Dominican mystic, said, *Haete der mensche niht me ze tuonne mit gote, dan daz er dankbaere ist, ez waere genuoc* ("If a man had no more to do with God than to be thankful, that would suffice").

—ALBERT HAASE, OFM (1955–), *Catching Fire, Becoming Flame*

Joyful, joyful, we adore Thee,
God of glory, Lord of love;
Hearts unfold like flow'rs before Thee,
Op'ning to the sun above.
Melt the clouds of sin and sadness;
Drive the dark of doubt away;
Giver of immortal gladness,
Fill us with the light of day!

All Thy works with joy surround Thee,
Earth and heav'n reflect Thy rays,
Stars and angels sing around Thee,
Center of unbroken praise.
Field and forest, vale and mountain,
Flow'ry meadow, flashing sea,
Singing bird and flowing fountain
Call us to rejoice in Thee.

Thou art giving and forgiving,
Ever blessing, ever blest,
Wellspring of the joy of living,
Ocean depth of happy rest!
Thou our Father, Christ our Brother,
All who live in love are Thine;
Teach us how to love each other,
Lift us to the joy divine.

Mortals, join the happy chorus,
Which the morning stars began;
Father love is reigning o'er us,
Brother love binds man to man.
Ever singing, march we onward,
Victors in the midst of strife,
Joyful music leads us Sunward
In the triumph song of life.

—Henry van Dyke (1852–1933)

142

All shall be well,
and all shall be well,
and all manner of thing shall be well.
—Julian of Norwich (c. 1343–after 1416)

SOURCES

Alcott, Louisa May. *Little Women*. Boston: Roberts Brothers, 1868.

Angelou, Maya. *Mom & Me & Mom*. New York: Random House, 2013.

Bryant, William Cullen. "The Evening Wind." In *Poems*. Boston: Hilliard, Gray, and Company, 1825.

Chesterton, G. K. "The Testament of Francis." In *The Collected Works of G. K. Chesterton: Collected Poetry: Part 1*. San Francisco: Ignatius, 1926.

Cutter, William. *The Value of Little Things*. Boston: D. Lothrop & Co, 1881.

de Amicis, Edmondo. *Heart: A Schoolboy's Journal*. Trans. Isabel Florence Hapgood. New York: Thomas U. Crowell & Co., 1885.

de Vinck, Chris. *Things That Matter Most*. Brewster, MA: Paraclete Press, 2022.

Dunbar, Paul Laurence. "A Thanksgiving Poem." In *Lyrics of Sunshine and Shadow*. New York: Dodd, Mead and Company, 1899.

Haase, Albert, OFM. *Catching Fire, Becoming Flame*. Paraclete Press, 2023.

Hopkins, Gerard Manley. "Pied Beauty" and "God's Grandeur." In *Poems of Gerard Manley Hopkins*. Oxford, UK: Oxford University Press, 1918.

Kamieńska, Anna. *Astonishments*. Paraclete Press, 2018.

Karr, Alphonse. *A Tour Round My Garden*. London, UK: George Routledge & Sons, 1856.

Keller, Helen. *The Story of My Life*. New York: Doubleday, Page & Co., 1903.

Lubbock, John. *The Use of Life*. London, UK: Longmans, Green, and Co., 1894.

McPherson, Thomas. "Giving Thanks." In *Essential Celtic Prayers*. Paraclete Press, 2017.

Merton, Thomas. *Thoughts in Solitude*. New York: Farrar, Straus and Giroux, 1956.

Mikhail, Phoebe Farag. *Putting Joy into Practice*. Paraclete Press, 2017.

Nouwen, Henri J. M. *The Dance of Life*. New York: Crossroad, 2005.

Nouwen, Henri J. M. *The Return of the Prodigal Son*. New York: Doubleday, 1992.

O'Donnell, Angela Alaimo. "Flannery's Gratitude." In *Andalusian Hours*. Paraclete Press, 2020.

Powell, Edward Payson. "An Old-Time Thanksgiving." In James Whitcomb Riley, *An Old Sweetheart of Mine*. New York: E. P. Dutton, 1888.

Reiss, Jana. *Flunking Sainthood Every Day*. Paraclete Press, 2011.

Sandburg, Carl. *Chicago Poems*. New York: Henry Holt and Company, 1916.

Schucman, Helen. *A Course in Miracles: Workbook for Students*. Tiburon, CA: Foundation for Inner Peace, 1975.

Shaw, Luci. *Eye of the Beholder*. Paraclete Press, 2018.

Shaw, Luci. *The Generosity*. Paraclete Press, 2020.

Smyth Jones, Edward. "A Song of Thanks." In *The Colored American Magazine*. New York: Colored Orphan Asylum, 1898.

Thoreau, Henry David. *Walden*. Boston: Ticknor and Fields, 1854.

Whittier, John Greenleaf. "The Worship of Nature." In *The Pennsylvania Pilgrim and Other Poems*. Boston: Houghton, Mifflin and Company, 1872.

Whittier, Matthew Franklin. "The Pumpkin." In *The American Review: A Whig Journal of Politics, Literature, Art, and Science*. Boston: Lee & Shepard, 1850.

◆ ABOUT PARACLETE PRESS ◆

Paraclete Press is the publishing arm of the Cape Cod Benedictine community, the Community of Jesus. Presenting a full expression of Christian belief and practice, we reflect the ecumenical charism of the Community and its dedication to sacred music, the fine arts, and the written word.

SCAN
TO
READ
MORE

YOU MIGHT BE INTERESTED IN...